IMAGES
of America

TALLAHASSEE

IMAGES
of America

TALLAHASSEE

Erik Robinson

ARCADIA

Published by Arcadia Publishing,
an imprint of Tempus Publishing, Inc.
2 Cumberland Street
Charleston, SC 29401

Printed in Great Britain.

Library of Congress Catalog Card Number: 2003106044

For all general information contact Arcadia Publishing at:
Telephone 843-853-2070
Fax 843-853-0044
E-Mail sales@arcadiapublishing.com

For customer service and orders:
Toll-Free 1-888-313-2665

Visit us on the internet at http://www.arcadiapublishing.com

I dedicate this book to my dear wife Sallie, who has always helped.

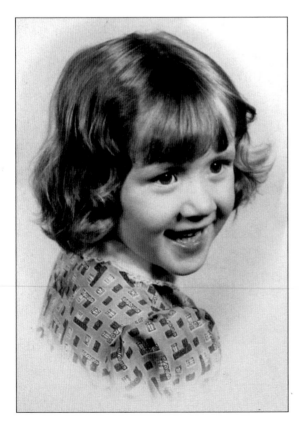

SALLIE ANN STURGIS. This is Sallie Ann Sturgis at about the age when she started traveling from her South Carolina home to Tallahassee to visit her aunt Clelia and uncle Griff Pugh. Dr. Pugh taught English at Florida State University beginning in 1947.

CONTENTS

ACKNOWLEDGMENTS

Many kind people helped me with this project. The majority of the images came from the photographic collection of the Florida State Archives. Allen Morris started the collection, and I thank him. Joan Morris continued the collection, and I thank her. Leslie Lawhon Sheffield is the archivist who helped, suggested, and found ways, and I thank her most gratefully. The following people also donated images: David Ferro, Bruce Smathers, Alvan Harper, Wayne Denmark, Cathleen Mannheimer, Dorothy Dodd, Rabbi Stanley Garfein, and Susan Harp. Some photographs came from my own collection. They deserve better than cardboard boxes. I vow to put them in acid-free storage . . . sometime soon.

The librarians at the State Library of Florida never once failed to find the information I needed. They are amazing people: Cherie Ellison, Cay Hohmeister, Cathy Moloney, and Judy Young.

The captions that identify these fabulous photographs have facts and dates that Sallie Robinson and others checked. They caught me a number of times, but the mistakes you may still find are entirely my own. Carolyn Lemon at Arcadia Publishing has helped me and reminded me with firm kindness of the goals and timelines, despite being distracted by her recent marriage. My thanks go to all these folks.

INTRODUCTION

History has a way of editing itself. Things get lost or stolen, people forget, or no one took a picture of a place or event. What's left is what we know about our past. So the pictures in this book show us lots of people, places, and events, but others are left out. Fortunately, Tallahassee, Florida is a vibrant and active collection of communities. If you, the reader, find something missing, you will probably find it in other books already written or in a book yet to be created.

This book takes a closer look at several of Tallahassee's significant communities, especially our state government, our institutions of learning, and some of the people and places that have made life in the capital city enjoyable and worthwhile. Very many Tallahasseans, whether natives, visitors, or students, have an involvement in these institutions. Generations of past Tallahasseans have experienced them as well, though often in a different form. Most of us have come to Tallahassee from somewhere else, to go to college for a few years before moving on, to take a job with state, county, or local governments, perhaps for a career or, more likely, for a few years before finding something else to do. We have our memories. With this book, we can find places that are now familiar and find out about what they once looked like. Surprisingly, some buildings have moved over the years, as well as people.

Florida Territorial officials created Tallahassee in 1824 specifically to serve as the capital city. Before that the area had been an Apalachee Indian capital during the Spanish period of Florida history. The area was also a regional center of the Spanish missions of colonial Florida. Throughout most of the 19th century the city served the state as its undisputed capital. In 1900, as Florida grew south down the east and west coasts of the peninsula, some people challenged Tallahassee's designation as Florida's capital. During the 1900 statewide Democratic primary (there was no Republican Party as yet), one of the ballot entries asked voters to mark one of four cities as their preference for state capital. Tallahassee won. As the population of the state grew, so did their needs. State government had to grow to meet some of the needs that could not be delivered by private individuals or institutions. The capitol building housed all three branches of state government until 1912. New office buildings have come along since then, until a sizable segment of downtown Tallahassee is now devoted to government. On a smaller scale, the same can be said of county and city government.

Well-to-do families sent their children to private school in Tallahassee before the Civil War. After the war, the federal government mandated public schools to educate the newly freed African Americans in the state. Once a school system existed, white children of all economic levels began attending as well. Segregation began separating the races in the 1880s until the

7

1960s, but both races recognized the importance of education. Two separate colleges and high schools operated in Tallahassee in the 19th and 20th centuries. They still operate today, though all the institutions welcome students on a non-discriminatory basis now.

In this new age of eco-tourism, we recognize the importance and economic impact of natural and cultural attractions. Florida, as a state, now has Disney World. Tallahassee has almost all that Disney offers, with one difference: the things we offer are real, not make-believe. The museums contain real Spanish doubloons, real artifacts that once belonged to Seminole Indian leader Osceola, the real home of Princess Murat (Catherine Gray of Tallahassee), and so on. City parks as well as state gardens and national wildlife refuges surround us. And because this is Florida, we can enjoy our attractions year-round.

These are some of the things you will see in this book. There are more. A future author will have plenty to picture and to write about. Meanwhile, relax and enjoy the people, places, and historic events of Tallahassee, Florida.

One

THE CAPITOL AND CENTER OF GOVERNMENT

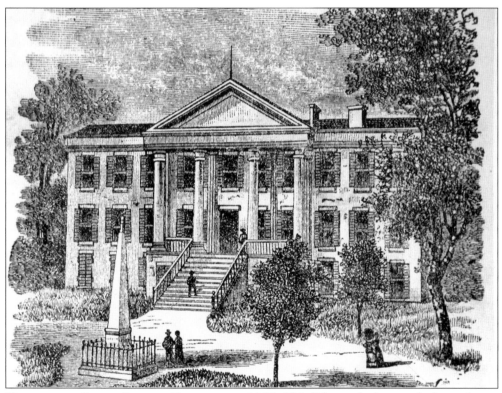

VIEW OF THE STATE CAPITOL BUILDING, C. 1885. This lithograph shows only four columns on the front, though the building had six. The monument in the front yard is still on view today; it memorializes Capt. John Parkhill, killed in the Third Seminole War in 1857.

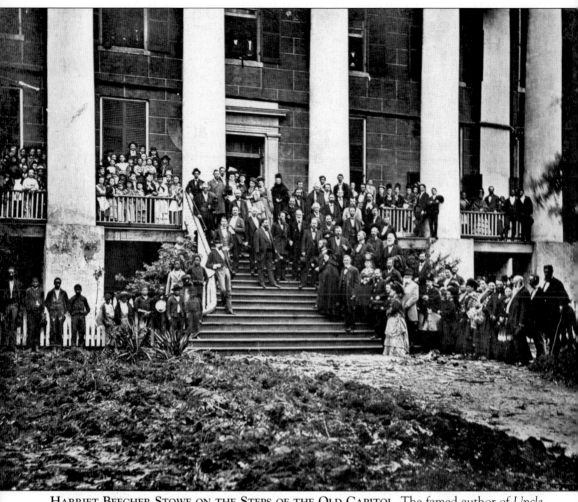

HARRIET BEECHER STOWE ON THE STEPS OF THE OLD CAPITOL. The famed author of *Uncle Tom's Cabin* visited Florida as a winter tourist for many years after the Civil War. She lived along the St. Johns River south of Jacksonville. Here she visits Tallahassee on April 10, 1874.

VIEW OF TALLAHASSEE FROM THE EAST STEPS OF THE CAPITOL BUILDING C. 1875–1880.
The fence kept out wandering cows and other livestock. Apalachee Parkway now graces the view from the capitol steps. Many trees still block city buildings from view.

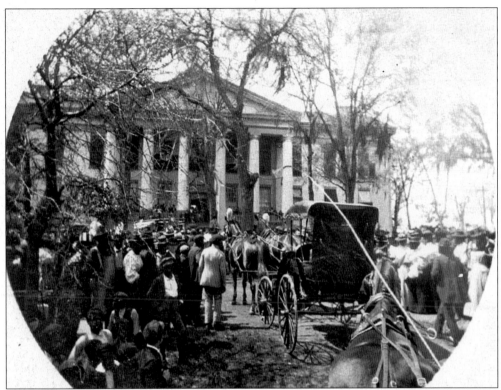

PRESIDENT WILLIAM MCKINLEY VISITS THE CAPITOL MARCH 27, 1899. Gov. William Bloxham waits for him on the capitol steps. The circular photograph was taken from the carriage behind the President's with a Kodak No. 1, the first consumer camera ever marketed.

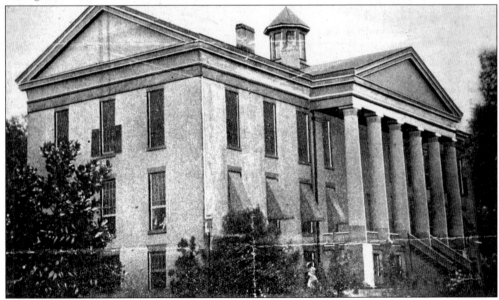

THE 1891 CUPOLA ON TOP THE CAPITOL. Florida voters decided the issue of where the state capital should be located in 1900. This photograph of the state house appeared on the cover of a pamphlet intended to persuade voters to keep the capital in Tallahassee. It worked.

ADDITIONS TO THE CAPITOL IN 1902. After Tallahassee triumphed in the 1900 vote to keep the capital, the 1901 legislature voted the extravagant sum of $75,000 to more than double the size of the capitol building, including a large and beautiful new dome.

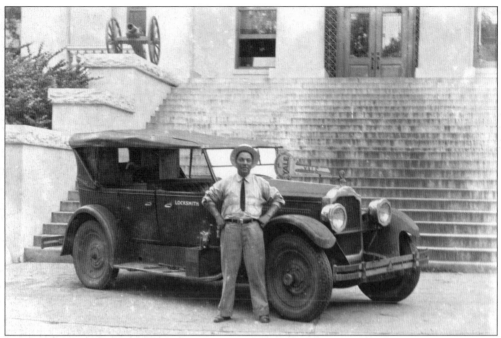

TALLAHASSEE LOCKSMITH AT THE EAST STEPS OF THE CAPITOL, C. 1927–1930. Many thousands of people have posed for their picture in front of the capitol. This tradesman stands proudly with his 1927 Packard Single Eight. Behind him rests one of a pair of Civil War–era mountain howitzers that graced the capitol entrance from about 1905 to 1979. They are now part of the Museum of Florida History collection in Tallahassee.

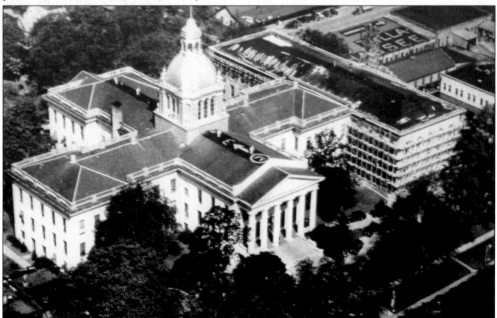

NEW ADDITIONS TO THE CAPITOL IN 1936. State officials planned two huge new wings to help serve Florida's growing population. This one, for the House of Representatives, went up on schedule. The second wing, for the Senate, had to wait until after World War II.

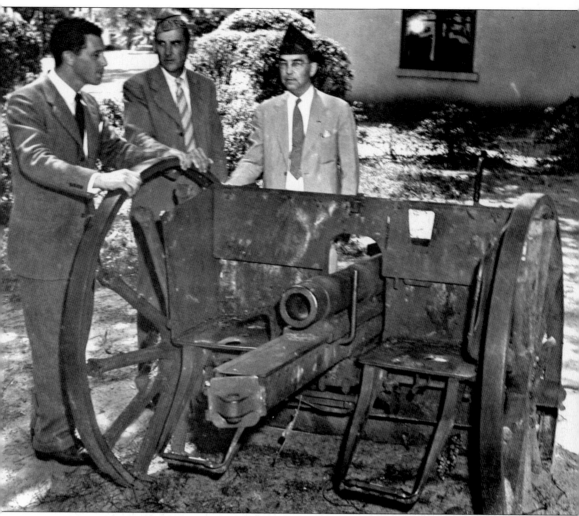

WORLD WAR I TROPHY CANNON ON THE CAPITOL GROUNDS, SEPTEMBER 1, 1942. State Senator LeRoy Collins (left), local American Legion Commander J. Ralph Hamlin (center), and Florida Secretary of State R.A. Gray (right) served on the Leon County Defense Council's Salvage Committee. They sent this German Model 1917 Krupp field artillery piece to be melted down and used for United States Army munitions in World War II.

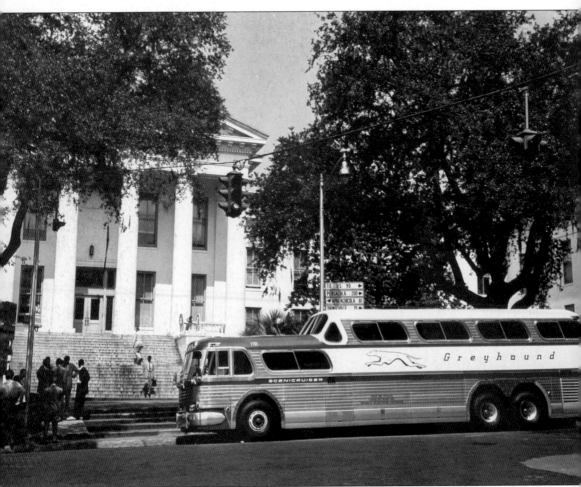

GREYHOUND "SCENICRUISER" IN FRONT OF THE CAPITOL, 1954. The capitol, with state government in operation, local museums, and historic sites, has long been a destination for school groups and others interested in history, as well as history-in-the-making.

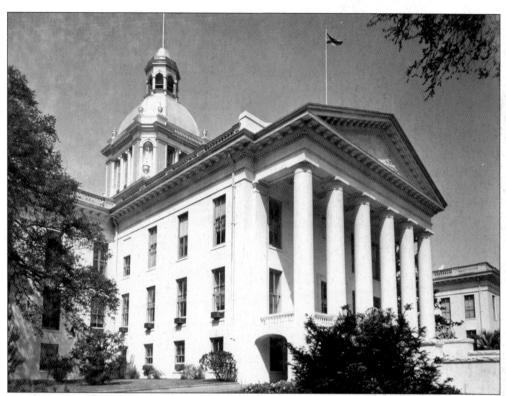

FLAGS FLYING AT THE CAPITOL, 1954. The state flag never flew regularly from the dome until Gov. Jeb Bush ordered it flown in 1999. Instead, it occupied a place of honor over the east portico of the building. When the old capitol was restored to its 1902 appearance, workers removed the portico and its flagpole. Notice as well the start of air conditioning in the building with a few window units in evidence.

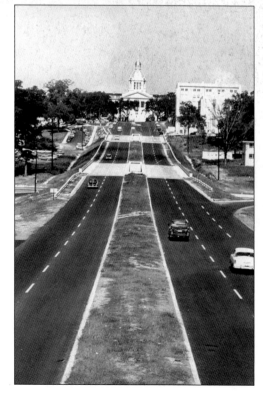

APALACHEE PARKWAY AND THE CAPITOL FROM THE SEABOARD AIRLINE RAILROAD BRIDGE, 1958. Though the area is now much more built up, the road remains a dramatic and vivid approach to the ceremonial center of state government.

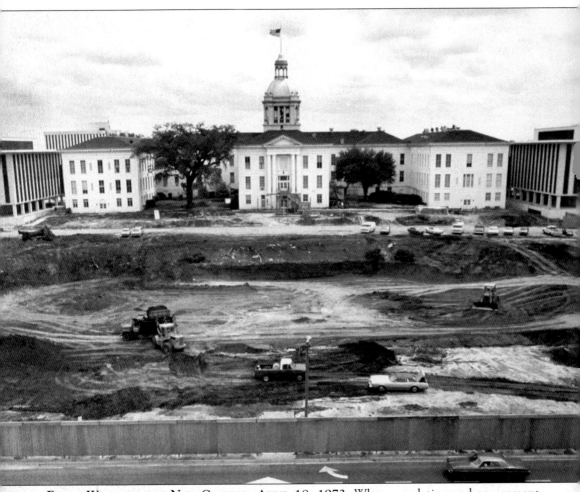

Early Work on the New Capitol, April 18, 1973. When population and government outgrew the 1947 addition to the capitol, Gov. Reubin Askew and the legislature commissioned a new capitol. In this photograph the house office building (left) and Senate Office Building (right) are already complete as workmen carve the foundation for the 22-story New Capitol.

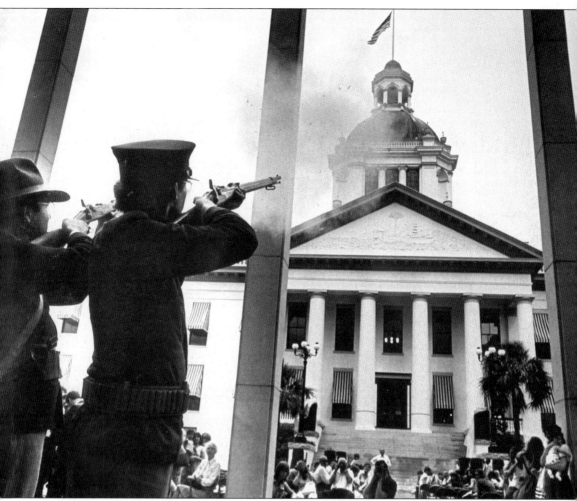

DEDICATION OF THE RESTORED OLD CAPITOL, SEPTEMBER 19, 1982. Military re-enactors with uniforms and weapons reproduced from the 1898 Spanish-American War period fire-up the start of the opening of the historic old capitol as a museum. New exhibits installed in the building in 2002 present serious and long-standing issues in Florida's past and present.

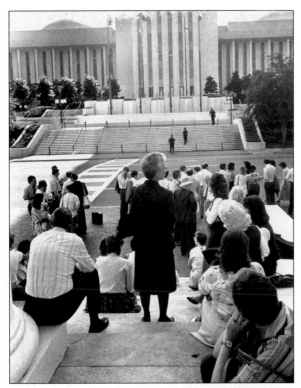

WEST FRONT OF THE NEW CAPITOL, JUNE 24, 1987. The five flags of Florida history—Spanish, French, British, Confederate, and the United States—flew from the plaza from 1975 until 2001. At that time elected officials' concern over the flying of a Confederate flag at the capitol prompted the move of the flags to the lobby of the R.A. Gray Building.

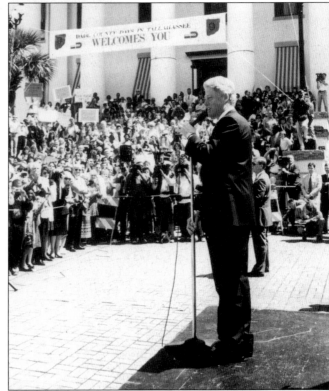

PRESIDENT BILL CLINTON IN THE PLAZA BETWEEN THE OLD CAPITOL AND THE NEW CAPITOL, MARCH 30, 1995. The brick-paved plaza plays host to a multitude of major and minor events and activities, especially during the annual March to May legislative sessions.

DEDICATION OF THE FLORIDA VIETNAM WAR MEMORIAL, NOVEMBER 11, 1985. Echoing the national memorial to the Vietnam War in Washington D.C., this striking monument includes the names of the more than 2,000 Florida citizens who died in service during that war. Located directly across the street from the capitol complex, a visit to this monument reminds visitors of the cost of war and the cost of freedom.

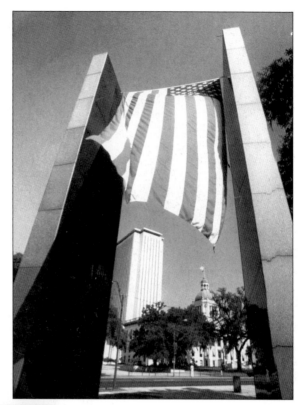

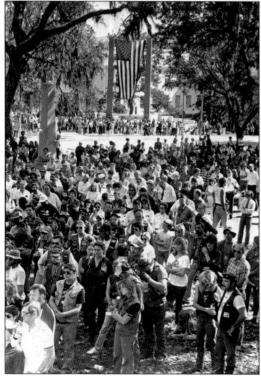

DEDICATION OF THE FLORIDA VIETNAM WAR MEMORIAL, NOVEMBER 11, 1985. Gov. Bob Graham spoke to a large crowd of veterans and families who attended the event. Remembrances of flowers and sometimes small objects continue to be left at the site to this day.

21

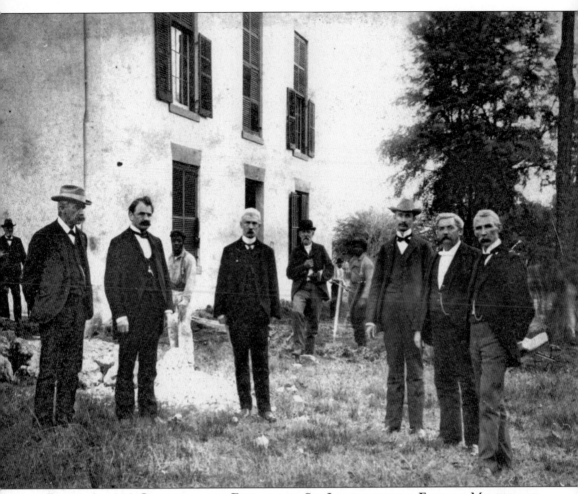

FLORIDA'S 1902 GOVERNOR AND FIVE OF THE SIX INDEPENDENTLY-ELECTED MEMBERS OF THE FLORIDA CABINET AT THE START OF THE FIRST EXPANSION OF THE CAPITOL BUILDING. In an age before massive earth-moving equipment, three black workmen already hard at work with shovels stand behind the elected leaders of state government. From left to right are Comptroller A.C. Croom, Gov. W.S. Jennings, Attorney General W.B. Lamar, Treasurer J.B. Whitfield, Superintendent of Public Instruction W.N. Sheats, and Commissioner of Agriculture B.E. McLin. (Secretary of State J. L. Crawford was not present.)

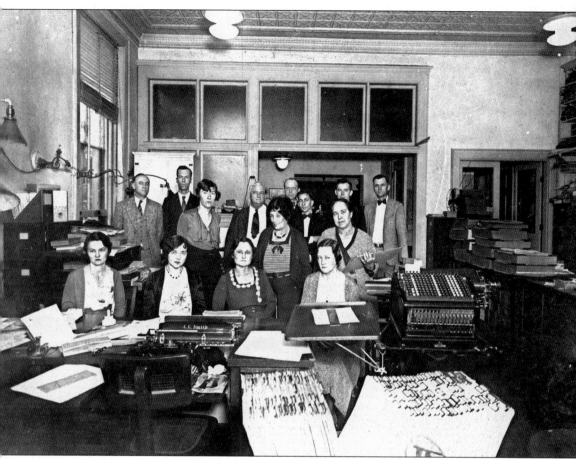

STATE WORKERS IN 1932. Members of the Comptroller's Office gather for a group photograph amid the files and mechanical calculators of their profession. The L.C. Smith typewriter and Burroughs calculator were the standard office technologies of the time. The Museum of Florida History displays examples of both machines in their collections.

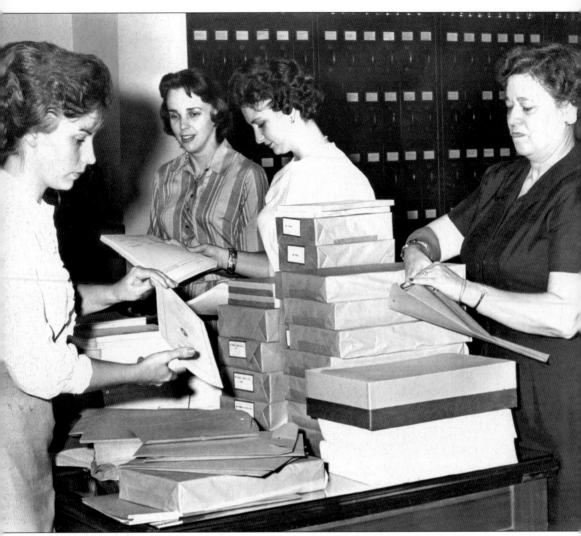

EMPLOYEES OF THE STATE DIVISION OF ELECTIONS, FEBRUARY 22, 1962. Division director Dorothy "Dot" Glissen (right) pitches in stuffing envelopes with information for candidates. She was later appointed interim Secretary of State by Gov. Reubin Askew. Behind the workers is a wall filled with the tall narrow wood and metal file cabinets in which most state records were tightly folded and stored for all of the 19th century and the first half of the 20th.

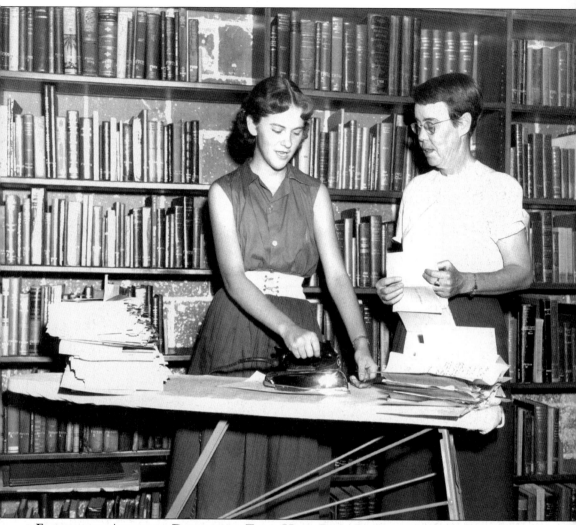

FLATTENING ARCHIVAL DOCUMENTS THAT HAVE BEEN FOLDED FOR OVER A CENTURY, JUNE 1, 1953. State librarian and founder of the State Archives of Florida, Miss Dorothy Dodd (right) worked for decades to find, rescue, and preserve important state records. Dr. Dodd's efforts culminated in 1969 with the official founding of the State Archives.

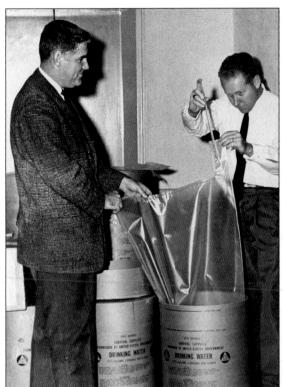

STOCKING A COLD WAR FALLOUT SHELTER IN THE CAPITOL BASEMENT, 1962. Gov. Farris Bryant designated the basement an official civil defense fallout shelter for 260 persons. Tallahassee city engineer Thomas P. Smith and federal civil defense officer Hal Miller add chlorine to plastic bags intended to hold drinking water. Other cardboard barrels held food, medicine, and sanitary supplies.

PRESS CORPS SKITS DURING THE 1985 LEGISLATIVE SESSION. Florida Gov. Bob Graham traded clothing with Key West rock star Jimmy Buffett to entertain and satirize the capital press corps. The annual event allows politicians and reporters to do and say things about each other that may be slightly "off color" but still in "good fun." Here they are singing "Wasted Away in Tallahassee" to the tune of Buffett's hit song, "Wasted Away in Margaritaville."

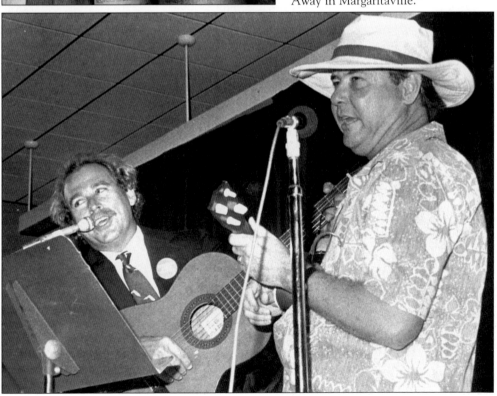

ON TOP OF THE OLD CAPITOL, NOVEMBER 22, 2002. Former Florida Secretary of State Bruce Smathers helped record the exact configuration of the roof and dome to enable a correct scale model of the structure to be built; it allowed visually impaired visitors to the historic site to experience the building's roof and dome. In 1977 and 1978, while serving as Secretary of State, Smathers refused to vacate the old capitol, preventing the possible premature bulldozing of the building before the legislature had voted to preserve and restore it. (Courtesy David Ferro and Bruce Smathers.)

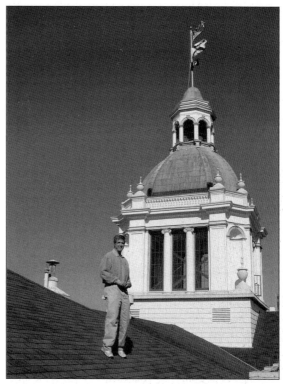

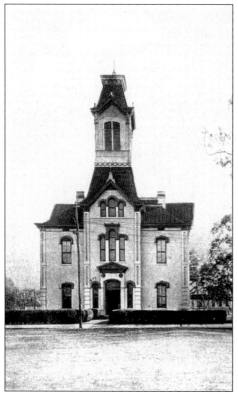

THE LEON COUNTY COURTHOUSE ON MONROE STREET, C. 1900. Built in 1882 after the first courthouse burned, the building displays the dramatic Victorian Second Empire style. Tallahassee has always been the only large urban center in the county, so there has never been any attempt to move the county seat elsewhere.

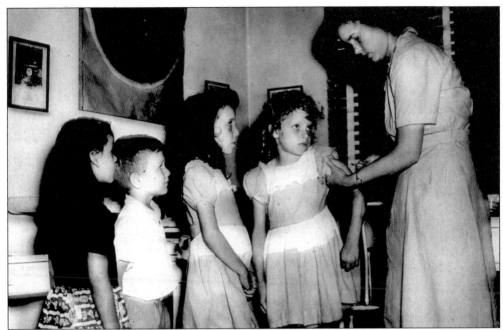

LEON COUNTY SCHOOL CHILDREN RECEIVING POLIO VACCINE, C. 1953–1955. Dr. Jonas Salk developed a vaccine against the dreaded polio illness between 1951 and 1953. A gigantic test involving almost two million school children took place in 1953, and by April 1955 both injections and vaccine-soaked sugar cubes were used for mass inoculations that virtually eradicated the disease. This photograph could have been taken during the 1953 test or at the beginning of universal immunizations. Leon County's Health Unit continues to be one of busiest and most valued branches of county government.

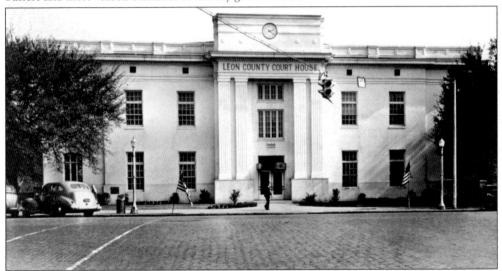

REMODELED LEON COUNTY COURTHOUSE, C. 1938. By 1924, the Victorian building looked out-of-date to officials. They "remodeled" it by taking off the 19th-century tower and "gingerbread" ornaments, and then enlarged the structure to accommodate services for an increasing population. The Art Deco styling of this exterior was used on many other Florida county courthouses as well.

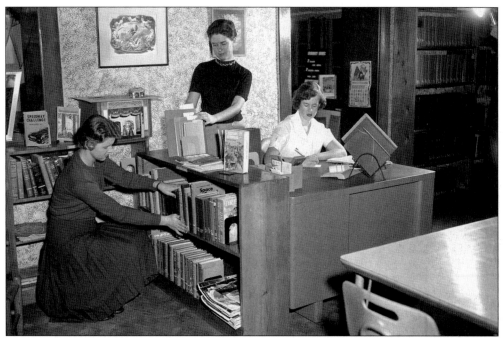

LEON COUNTY PUBLIC LIBRARY, 1957. Libraries are a vital part of any community or government. Former Florida governor David Shelby Walker (served 1865–1868) opened his personal book collection as the first paying subscription library in Tallahassee in the late 19th century. A free public library only started on March 21, 1956 in the basement of the building now used as the Tallahassee Visitor's and Convention Bureau. The structure is called "The Columns" and is one of the oldest remaining structures in Florida, dating to 1830–1832.

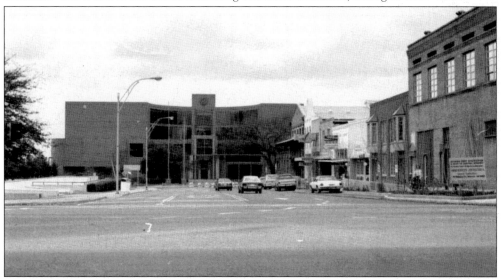

TALLAHASSEE'S NEW CITY HALL, 1985. As the city population grew after World War II, demand for government services rose as well. This ultra-modern building, located only a block from the county courthouse and across the street from the state capitol, serves as both an administrative center and a cultural center, presenting numerous programs and exhibits for the public's benefit, from paintings and sculpture to quilts and music.

Fourth of July Fireworks at Tom Brown Park, 1985. Tallahassee Parks and Recreation puts on the biggest celebration in town every Independence Day at the city's largest public recreation facility. At this and other parks, enthusiasts can also play tennis, baseball, soccer, and volleyball, ride bicycles, zoom around on skateboards and roller skates, and enjoy a multitude of other sports and activities.

Two

CITY SCENES AND STREETS

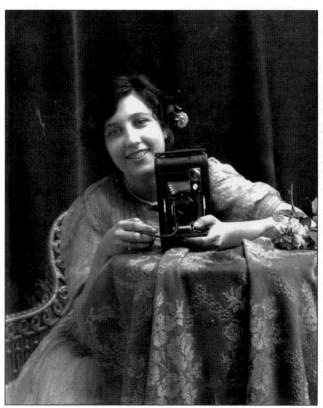

WOMAN WITH KODAK NO. 4A FOLDING CAMERA, C. 1906–1910. Alvan Harper served as Tallahassee's first resident professional photographer, working from 1885, when he moved here from Philadelphia, until his death in 1910. He took for his subjects black and white citizens, their homes and farms, animals, city streets, the dashing young men of the local high-wheel bicycle club, and some whimsical subjects, such as this woman posed as if taking the viewer's picture while having her own made.

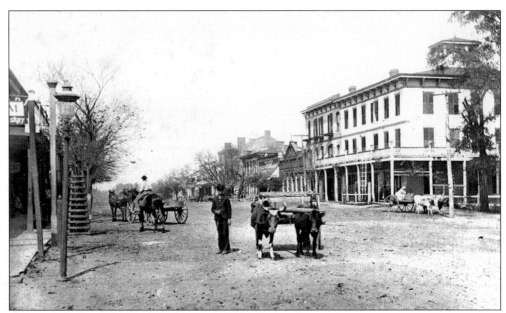

TALLAHASSEE'S CENTRAL BUSINESS DISTRICT, C. 1890. Citizens could not enjoy paved streets in the city until the 1920s. This end-of-the-century image was taken at the corner of Monroe and Jefferson Streets, just past the county courthouse. It looks north up Monroe Street where the SunTrust Bank building is now. Then the St. James Hotel stood on the site. No electricity existed in town yet, but it would within a decade.

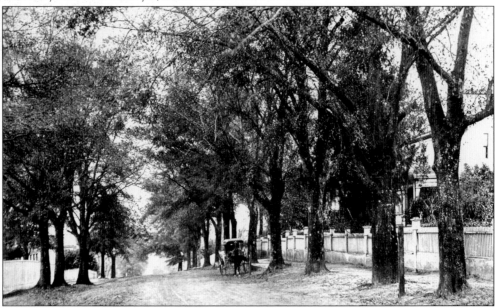

DOWNTOWN TALLAHASSEE, C. 1890. This view shows College Avenue from Adams Street looking west toward the area where Westcott Hall would be built a couple of decades later. College Hall, not visible in this photograph, served the students of West Florida Seminary. The college had been operating there since 1857. To the right through the trees stands the antebellum home of Robert Gamble, once president of the Union Bank. The First Baptist Church now occupies the lot.

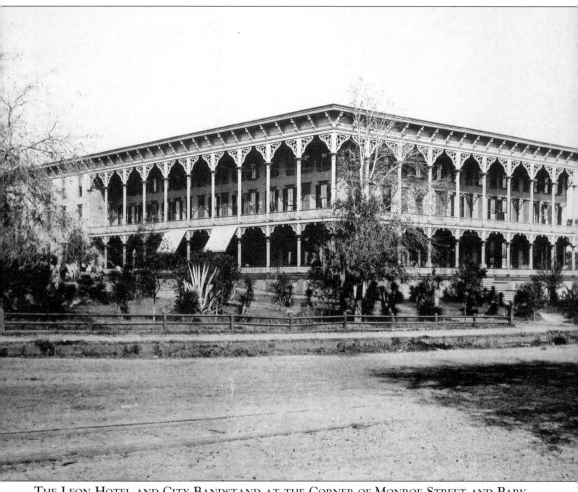

THE LEON HOTEL AND CITY BANDSTAND AT THE CORNER OF MONROE STREET AND PARK AVENUE, C. 1915–1925. Like most towns in 19th- and early-20th-century America, the city bandstand stood near the center of town. The Leon Hotel, the largest and most elegant in Tallahassee, saw its rooms filled with legislators and lobbyists every other year. There were permanent residents of the hotel as well, such as Miss Ruby Diamond. Built in 1885, it burned in 1925. The post office, now the Federal courthouse, replaced it.

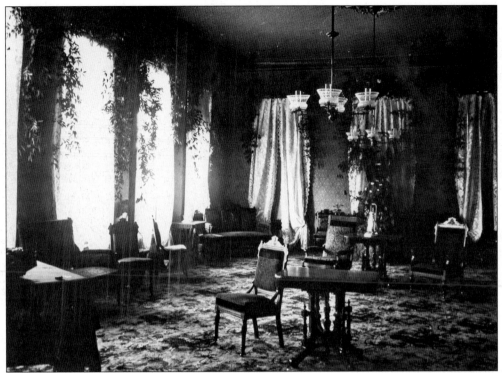

PARLOR OF THE LEON HOTEL, C. 1885–1890. Filled with Renaissance Revival and Eastlake-style furniture, Wilton carpets, and beautiful glass and brass chandeliers that burned illuminating gas, this parlor was the last word in Victorian elegance. Photographer Alvan Harper's image compares well with a later photograph of the parlor from the 1920s below.

PARLOR OF THE LEON HOTEL, C. 1920–1925. The interior space remains much the same 35 years later, though the wall stenciling, steam radiators, and furniture are more up-to-date.

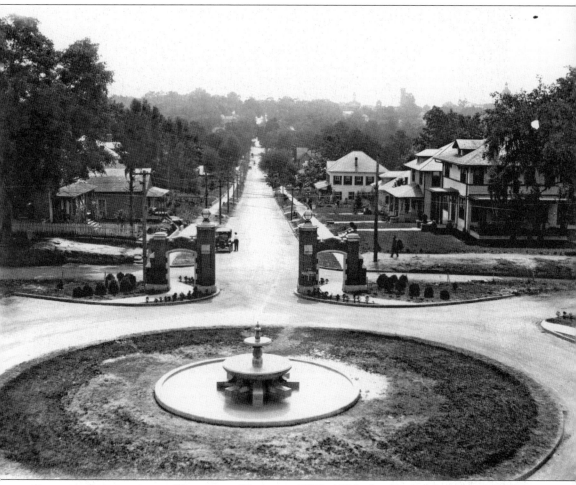

COLLEGE AVENUE FROM WESTCOTT HALL, C. 1920–1925. In the late teens and 1920s workmen began paving Tallahassee streets, building sidewalks, and creating urban amenities. The ceremonial entrance to the campus of Florida State College for Women received a landscaped fountain and a decorative brickwork gate. Most of the fine houses along College Avenue belonged to professors and administrators.

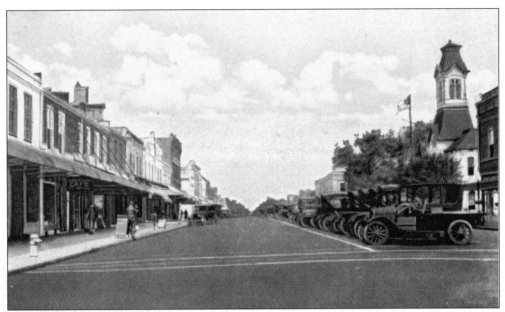

MONROE STREET NEAR JEFFERSON, C. 1923–1924. City fathers solved the growing automobile traffic problem by designating the middle of the street as a parking zone. The main streets of Tallahassee started getting paved during the 1910s and 1920s, and the "old" Victorian courthouse would soon be remodeled into a "modern" Art Deco structure.

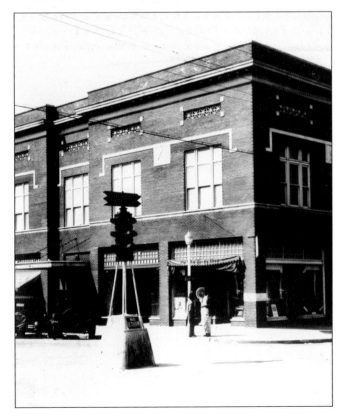

TRAFFIC SIGNAL FOR CARS AT ADAMS STREET AND COLLEGE AVENUE, C. 1927–1929. Five new electric traffic signals went up at busy downtown intersections in 1927. No word has come down to us about whether these signals created long waits or were timed to make the cars stop at each and every traffic light.

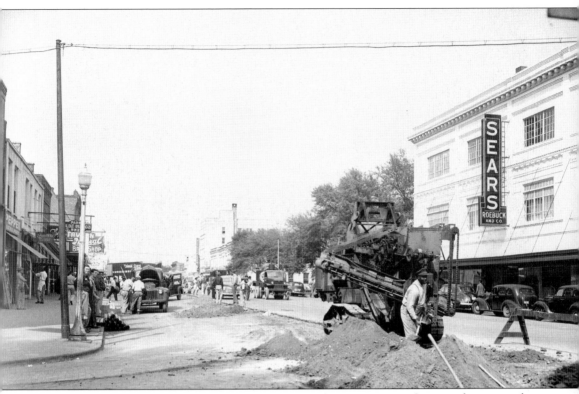

Road Repair at Monroe Street and Pensacola Streets, 1948. Once roads are paved, of course they need to be repaired. There appears to be a long line of traffic backed up down the street. Well, this is Florida, after all.

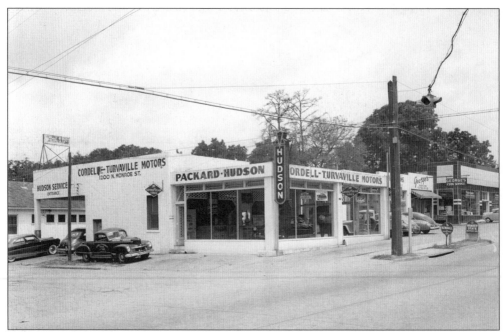

CORDELL-TURAVILLE MOTORS, JUNE 1948. Located on North Monroe Street, this dealership sold luxury Packard and Hudson automobiles. Both lines went out of business about 10 years after this photograph was taken.

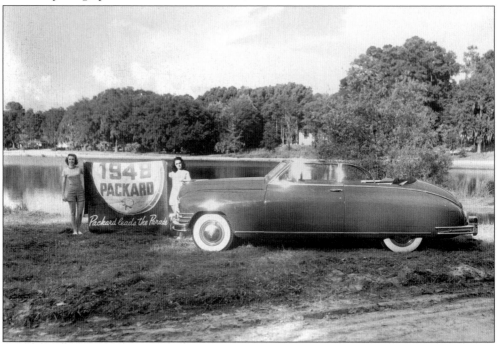

CORDELL-TURAVILLE MOTORS AT LAKE ELLA, AUGUST 1947. Scenic Lake Ella, two attractive young women, and a convertible provide the ideal opportunity to show off the new 1948 model Packard. Lake Ella at least is still with us and still a wonderful place to walk, talk, and feed the ducks and turtles.

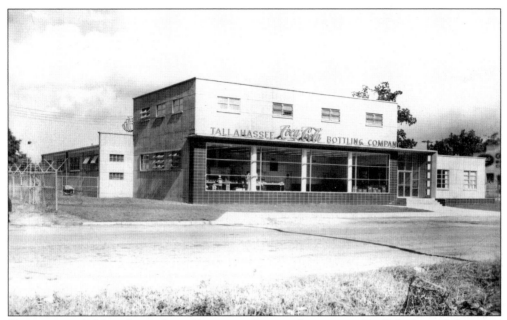

TALLAHASSEE'S NEW COCA-COLA BOTTLING PLANT, AUGUST 1949. Coke located their new plant on South Monroe Street just past the railroad bridge. Just over 50 years later, in 2000, the soft drink plant moved out to Capital Circle Northwest near Interstate 10. An eight-foot topiary in the shape of a classic Coca-Cola bottle went with the move.

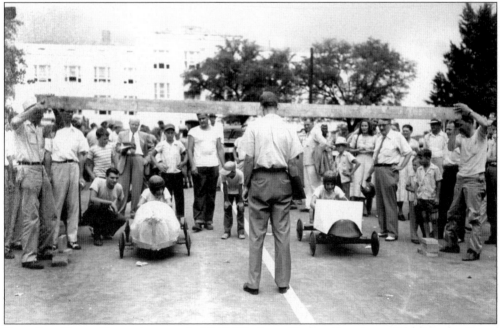

SOAP BOX DERBY RACE, AUGUST 3, 1949. The Leon County Courthouse faces Monroe Street in the background of this race, which took place on Jefferson Street. Soapbox races were once a very popular pastime. The Tallahassee Optimist Club sponsored this race. "Little Bobby Bryson," aged 12, won the derby in five races before a crowd of 2,000 spectators on a cloudy Wednesday afternoon.

SOUTH MONROE ANIMAL HOSPITAL, C. 1940. Dr. Paul Vickers started the earliest veterinary facility in Tallahassee, about 1938. He worked with Drs. Robert Lee and Waldo Palmer for many years. Later, Drs. Lomax Teal and Robert Duncan ran the business. It continues to operate today. In the early 1930s when the building was constructed and before it was a veterinary clinic, stories circulated that it operated as a "blind tiger" or unlicensed tavern selling illegal alcohol. (Courtesy Cathleen Mannheimer.)

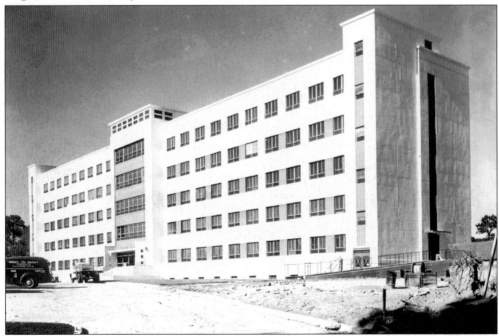

TALLAHASSEE MEMORIAL HOSPITAL, DECEMBER 1949. Until TMH started, many Tallahasseans traveled to John D. Archbold Memorial Hospital in Thomasville, Georgia to undergo surgery. In 1945, the City of Tallahassee took over the former military hospital facility at Dale Mabry Field southeast of the city. In 1949 a permanent home opened at the corner of Miccosukee and Magnolia Roads. TMH has expanded many times in the last half-century.

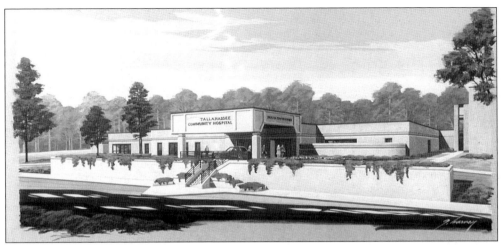

TALLAHASSEE COMMUNITY HOSPITAL, 1979. Hospital Corporation of America opened this for-profit facility in 1979 in a quiet area that was far outside the built-up area of the city at the time. The two-lane Capital Circle has enlarged to six lanes, many doctor and professional offices now surround the facility, and they are building a large new building. (Author's collection; Courtesy Tallahassee Community Hospital.)

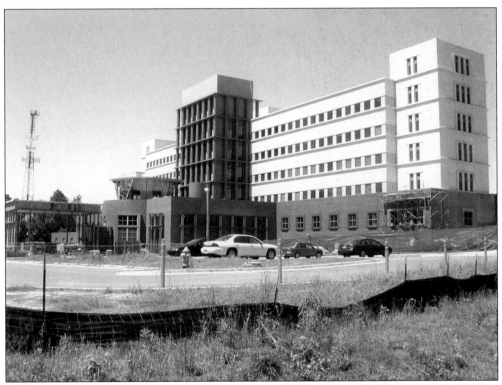

TALLAHASSEE COMMUNITY HOSPITAL, APRIL 2003. TCH's new building was scheduled to open for patients in October 2003. Its design looks surprisingly close to the original 1949 design of Tallahassee Memorial Hospital. (Author's collection.)

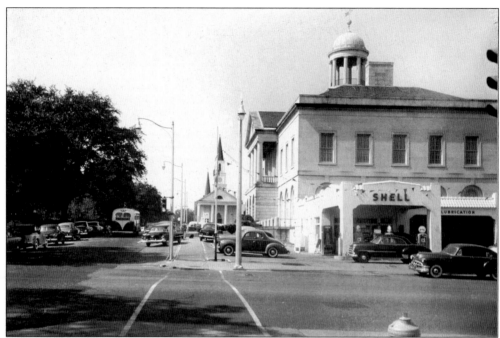

LOOKING DOWN PARK AVENUE FROM MONROE STREET, OCTOBER 25, 1952. Once the site of the luxurious Leon Hotel, the large neoclassical building on the right of this photograph housed the post office and later the United States district court. Visitors can still see five large historical murals in the entrance lobby, commissioned in the 1930s by the Works Progress Administration. Today, in the park across the street, a farmers market takes place every Saturday in the summer.

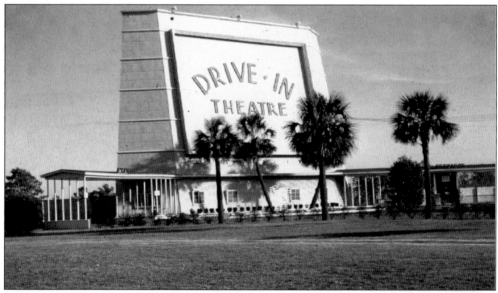

TALLAHASSEE DRIVE-IN THEATER, 1954. Located near the Leon County fairgrounds south of Orange Avenue, this icon of 1950s car culture once attracted crowds of adults and teenagers. One of over 150 drive-ins in Florida, it flourished during the golden age of drive-ins in the late 1950s and early 1960s.

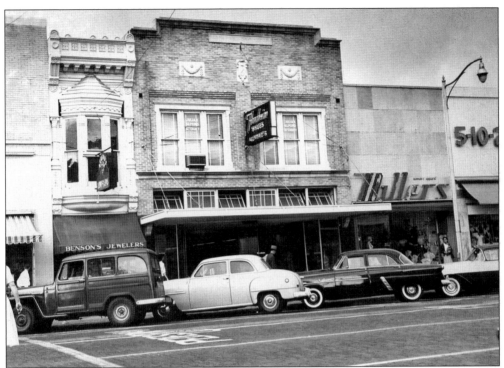

BUSINESSES ON THE WEST SIDE OF MONROE STREET BETWEEN JEFFERSON AND COLLEGE AVENUES, 1955. This everyday scene in the central business district shows two buildings that have survived from the late 19th and early 20th centuries: Benson's Jewelers and Florsheim Shoes. Both stores now have new occupants but they remain true to their original style. Note, too, that Monroe Street had brick paving. It probably still exists under the layers of asphalt that now cover the street.

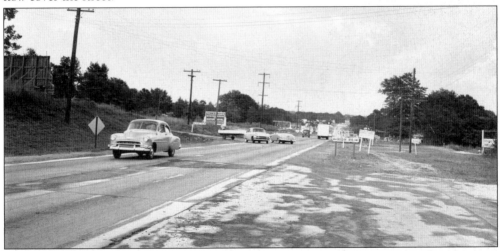

TENNESSEE STREET AT THE INTERSECTION OF HIGH ROAD, 1955. For visitors today, this quiet two-lane country road with little or no construction along the roadside bears no resemblance to the busy six-lane highway with strip malls and numerous traffic lights all along its corridor. Very many places in both Tallahassee and Florida generally have undergone this kind of extreme transformation.

43

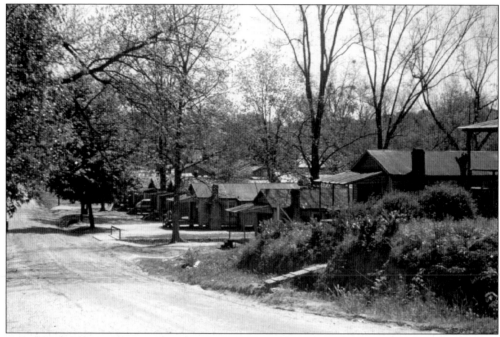

SMOKEY HOLLOW NEIGHBORHOOD, APRIL 3, 1955. This neighborhood is said to have received its name from the wood fires built by black residents when they boiled water for washing clothes.

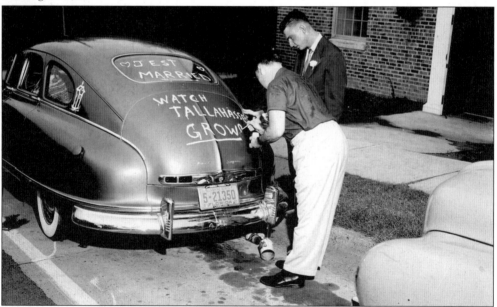

TALLAHASSEE WEDDING, 1957. Although the circumstances of this photograph have not come down to us, the situation is one most people can relate to. The friends of the bride and groom are decorating a 1951 Hudson Super 6 car while the wedding party is still in the church. The motto being painted on the car trunk, "Watch Tallahassee Grow," has come true in a very comprehensive way. There are more people, more buildings, and more activity than ever before. And, don't forget the tin cans tied to the bumper.

44

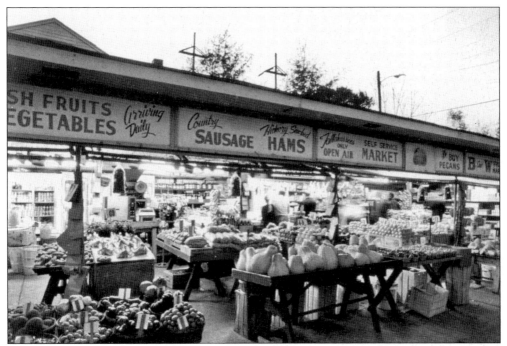

THE B&W FRUIT MARKET ON SOUTH MONROE STREET, C. 1955–1960. Located just south of all the government buildings around the capitol, this modest market offered fresh fruits and vegetables as well as various seasonal foods for many decades, finally closing in the late 1990s.

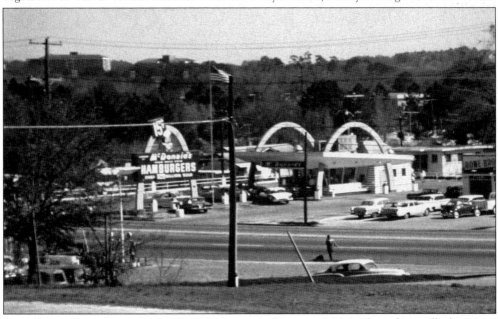

FAST FOOD RESTAURANT ON WEST TENNESSEE STREET, 1964. If gasoline sells for 31¢ a gallon, this must be the 1960s, right? An old-style McDonald's with the full-sized "golden arches" is positioned to appeal to the college students who swarmed up and down this section of Tennessee Street all day and into the night. The giant neon sign in front of the restaurant features 15¢ hamburgers.

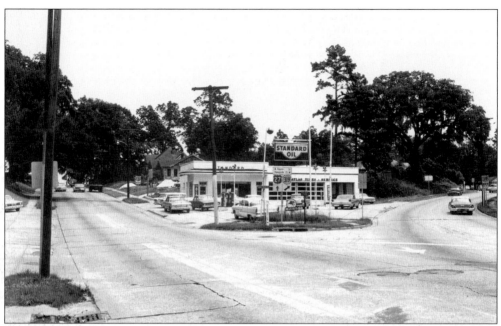

INTERSECTION OF NORTH MONROE STREET AND THOMASVILLE ROAD, AUGUST 9, 1966.
This now-busy intersection was only a pair of two-lane roads that did not even need a traffic light. Larger buildings housing businesses and professional offices have replaced the gas station. Many of the trees and single-family homes are also gone from this pleasant scene.

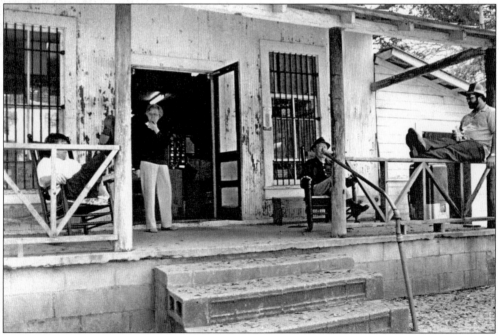

BRADLEY'S COUNTRY STORE ON CENTERVILLE ROAD, MARCH 4, 1983. Part of the charm of this old family business is that almost nothing has changed over the years. They continue to make their own brand of sausages and sell kerosene lamps, among other products. The chairs on the porch may need to be replaced in the near future, as they get a lot of use.

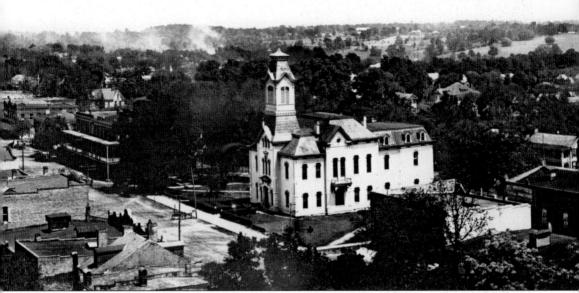

DOWNTOWN TALLAHASSEE FROM THE DOME OF THE CAPITOL, C. 1910–1913. The photographer took this picture as part of a series of five views that constituted a panorama of the city. This view shows the 1885 county courthouse facing Monroe Street along the building's narrow facade. Low houses surround the courthouse building. Across the street stands a row of businesses. There are farm fields in the distance and smoke to the northeast.

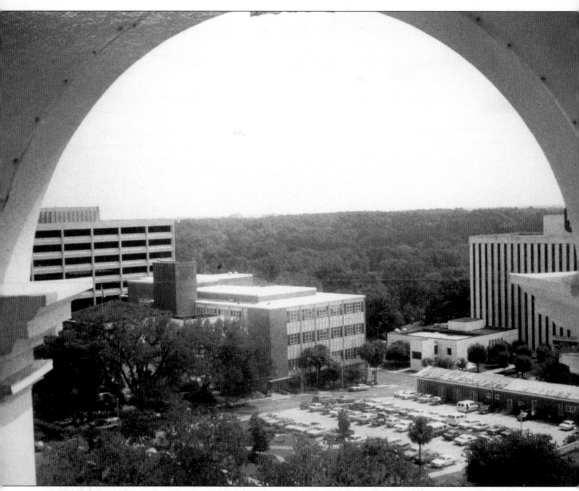

Downtown Tallahassee from the Dome of the Capitol, July 18, 1984. The old Leon County courthouse is almost unrecognizable from its numerous remodelings. The view is the same as the 1910 photograph. South Monroe Street moves off at a diagonal to the left. In three-quarters of a century, though, the landscape behind the downtown has grown up and is completely covered by trees, despite the fact that the once-open fields are now filled with streets, homes, and businesses. (Author's collection.)

Three
HIGHER EDUCATION

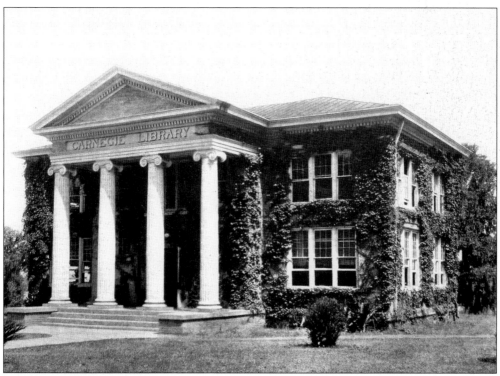

CARNEGIE LIBRARY AT FLORIDA AGRICULTURAL AND MECHANICAL COLLEGE, C. 1910.
When the original library of the State Normal College for Colored Students (founded in 1887) burned in 1905, the college president applied to millionaire industrialist Andrew Carnegie. The robber baron-turned-philanthropist agreed to include the school in his nationwide program of library building, and a beautiful neo-classical two-story library resulted in 1908. It remains the only Carnegie library located at a black land grant college. The restored building is now the home of the nationally renowned Black Archives, Museum, and Research Center, founded by Prof. James Eaton in 1971.

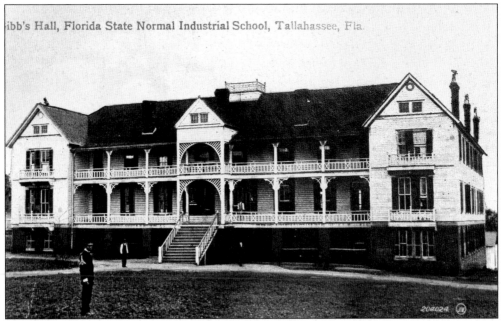

ibb's Hall, Florida State Normal Industrial School, Tallahassee, Fla.

GIBBS HALL AT FLORIDA STATE NORMAL AND INDUSTRIAL SCHOOL FOR NEGROES, C. 1910. Named for one of the founders of the university, Thomas Vann Gibbs, the building was used by the college as a residence hall for women. Fire destroyed the structure in January 1924. Thomas Gibbs's father Jonathan Gibbs served as Florida's first black Secretary of State and the first Superintendent of Public Instruction (today's Commissioner of Education). Both father and son are buried in Tallahassee's Old City Cemetery.

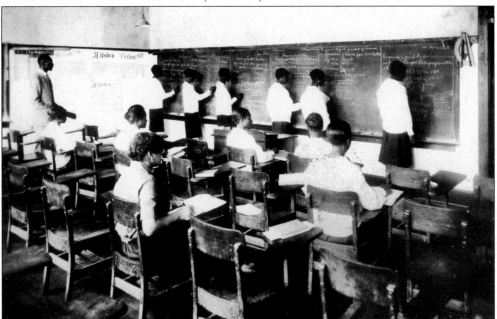

FLORIDA A&M COLLEGE MATHEMATICS CLASS, EARLY 1920s. Unlike the state's white colleges in the first half of the 20th century, A&M was always a coeducational school. Students appear to be demonstrating blackboard work with different kinds of mathematical problems.

50

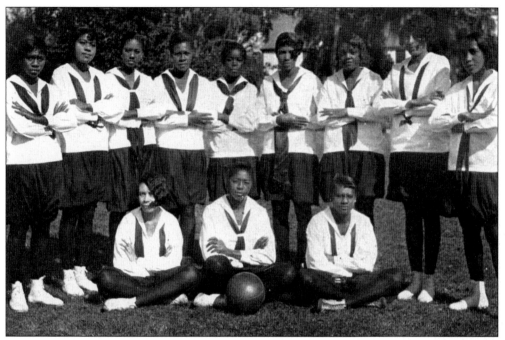

FLORIDA A&M COLLEGE GIRL'S BASKETBALL TEAM, 1929. The uniforms these young women wear must have made some plays more difficult to execute, though they are certainly quite modest by comparison with today's sports uniforms.

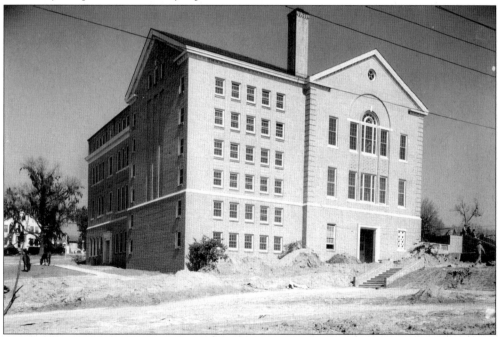

COLEMAN LIBRARY ON THE CAMPUS OF FLORIDA A&M COLLEGE, 1948. After World War II the Carnegie Library no longer sufficed for the needs of a growing student population. The new library building, named for Mr. Samuel H. Coleman (class of 1906), a longtime alumni booster and president of the college alumni association, opened shortly after this photograph was taken.

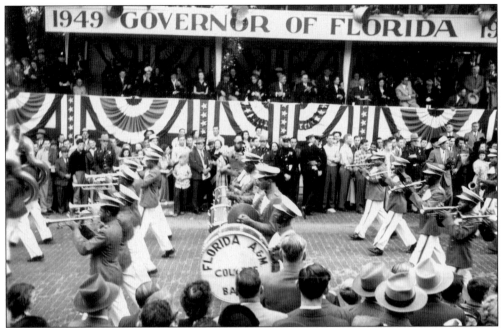

FLORIDA A&M MARCHING BAND IN THE INAUGURAL PARADE OF GOV. FULLER WARREN, JANUARY 4, 1949. Not yet known as the "Marching 100," the band marches in strict formation down the brick-paved Monroe Street. Governor Warren's inauguration was recorded by a radio station in Jacksonville and can be heard by researchers today at the Museum of Florida History.

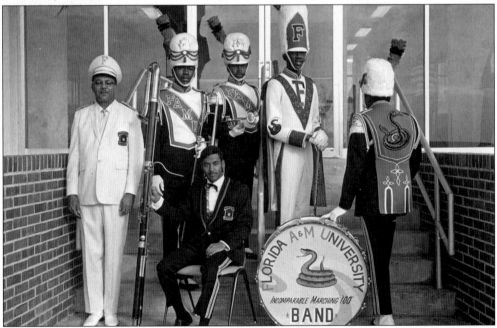

MEMBERS OF FLORIDA A&M UNIVERSITY'S "MARCHING 100" BAND, 1959. The band became an internationally recognized institution under the longtime direction of band director Dr. William P. Foster. They have played at the Rose Parade, United States Presidential inaugurations, and in Paris at that nation's bicentennial celebration of Bastille Day in 1989.

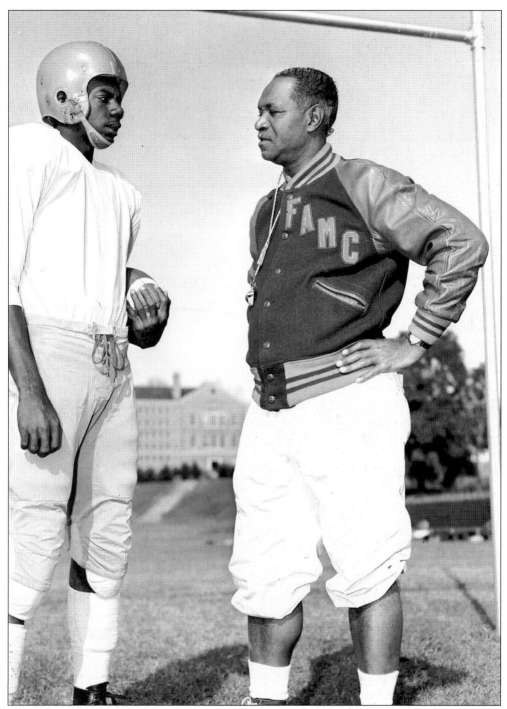

FLORIDA A&M FOOTBALL COACH ALONZO "JAKE" GAITHER, AUTUMN 1953. Jake Gaither became the best-known black college coach in America during his tenure at A&M. A number of his students went on to highly successful careers in professional football. Coach Gaither's teams won six national championships during his 25 years as head coach, between 1944 and 1969. His oft-quoted motto was, "I like my boys agile, mobile, and hostile."

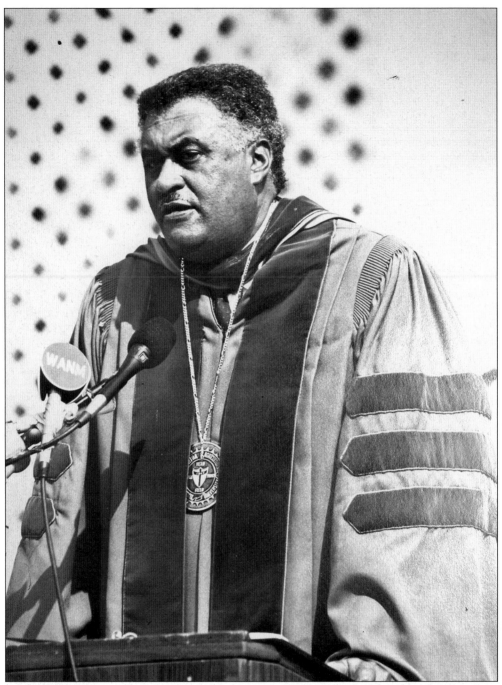

FLORIDA A&M PRESIDENT FREDERICK HUMPHRIES, OCTOBER 3, 1986. Dr. Humphries spoke at his inauguration as president of the university. The institution expanded its student body and its academic reputation during his 16-year tenure. He retired in 2002.

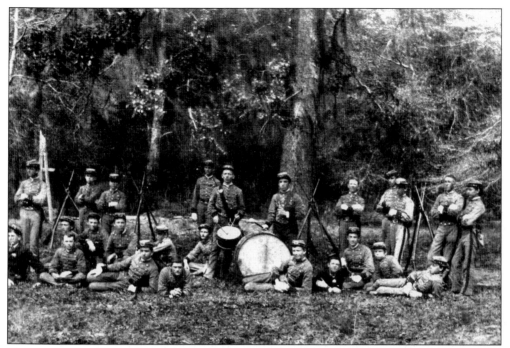

CADETS OF THE WEST FLORIDA SEMINARY, 1870S. Classes started in 1857, and only eight years later cadets participated in one of the last battles of the Civil War, at Natural Bridge south of Tallahassee on March 6, 1865. The school later became Florida State University.

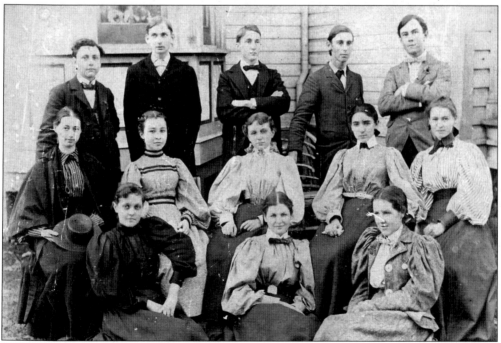

WEST FLORIDA SEMINARY'S NATURALIST'S CLUB, 1897. This school became co-educational in 1882. The young women display the height of fashion with their mutton-chop sleeves. The young men wear coats and ties—probably normal attire for class. All this in the Florida sun!

STATE COLLEGE FOR WOMEN (FSCW), THE MARY (MERRY) CLUB, 1910. When the state legislature reorganized the state universities in 1905 under the Buckman Act, the college became Florida State College for Women.

These students appear to be having a very good time indeed. The only criterion for joining this club was to have the name "Mary." FSCW became one of the top women's colleges in the nation by the 1930s.

FSCW Students at Lake Bradford, c. 1920. Now known as the "Seminole Reservation," this recreational facility then went by the name of "Camp Flastacowo."

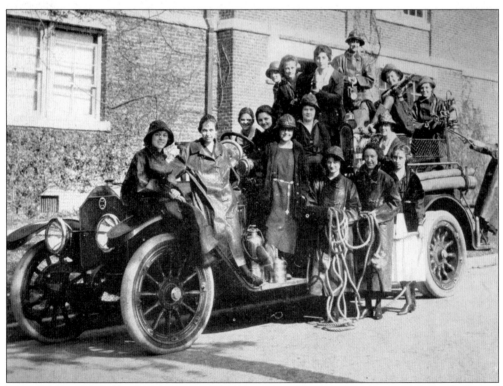

The Campus Fire Department at FSCW, 1921. These women practiced fire drills and organized safety lectures in the dorms. They posed for this photograph in a borrowed City of Tallahassee fire truck.

FSCW President Edward Conradi, 1925. Dr. Conradi came to Florida State in 1909, succeeding the able Dr. Albert Murphree. He remained at the helm of the college until June 1941. This photograph shows him in front of the Westcott Administration building. The new president's force of personality and skill helped increase the student body, the physical plant, and the size of the campus 10 times over during his tenure.

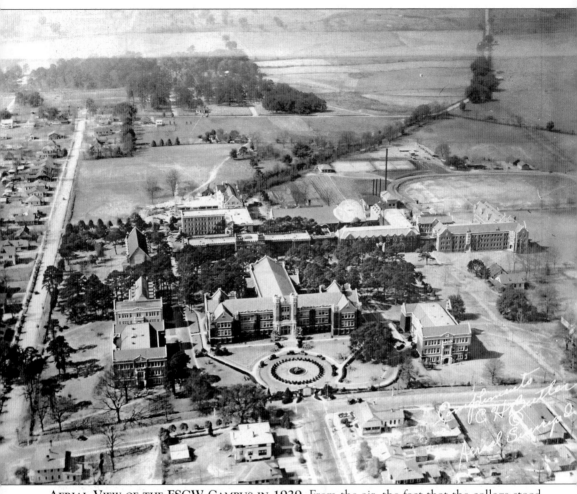

AERIAL VIEW OF THE FSCW CAMPUS IN 1929. From the air, the fact that the college stood on the edge of town is quite evident. Also, the ceremonial entrance to the campus, Westcott Hall with its walks, landscaping, fountain, and wrought-iron entrance gate, stands out dramatically. The campus, though small by comparison with today's campus, was a large one by 1920s standards.

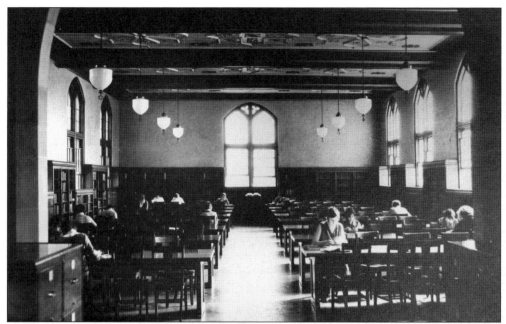

INTERIOR OF DODD HALL, C. 1930. The heart of any educational institution is its library. Dodd Hall, named for the longtime dean of the College of Arts and Sciences, served as FSCW's library from 1923 until 1957, when Florida State University built the new Strozier Library. The beautiful Neo-Gothic entrance and interior of Dodd Hall have been restored to its 1920s and 1930s splendor. The building is well worth a visit just for the pleasure of seeing the architectural magnificence that was once considered worthy of a library.

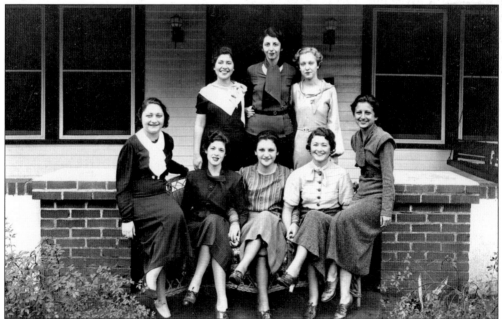

FSCW FRESHMEN PLEDGES, AUTUMN 1933. Fraternal organizations were and are an important part of most large universities. FSCW was no exception. This sorority chapter recruited Jewish women for its membership.

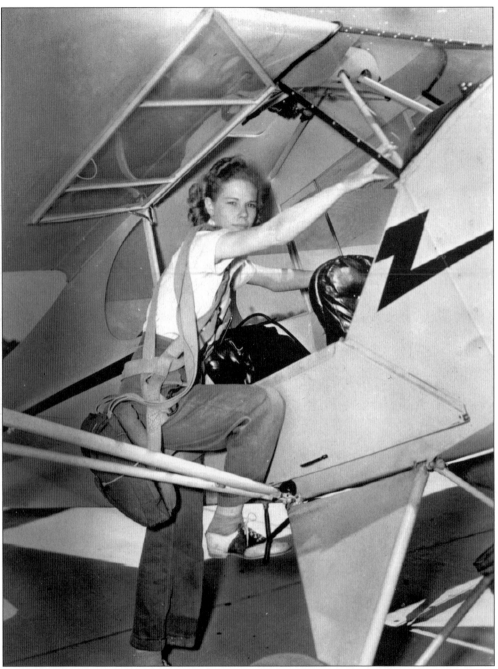

FSCW Flight Class, Spring 1940. Miss Jean McRae, of Homosassa, climbs into the cockpit to make a solo flight. Some of the flight graduates may have joined Florida native Jacqueline Cochran as WASPs (Women's Air Force Service Pilots) during World War II.

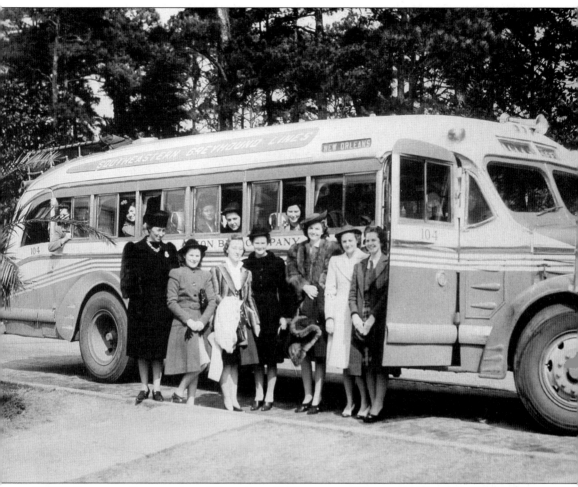

FSCW Students Leaving for [Christmas?] Vacation, Winter 1940–1941. This group of young women poses in front of an interstate bus. Despite the fact that they were traveling long-distance, information with the photograph stated "No young lady left campus without hat, gloves, and hose."

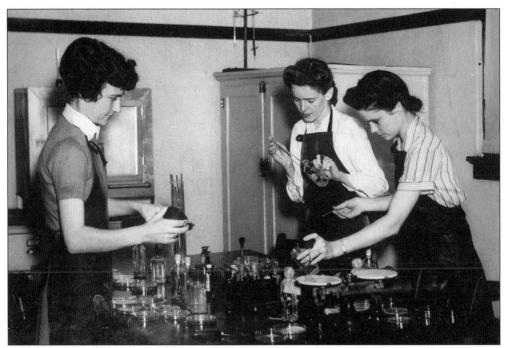

FSCW Students in Chemistry Laboratory, c. 1941–1942. Florida State offered a serious education that many young women used to pursue independent careers as well as to take a knowledgeable place in their communities.

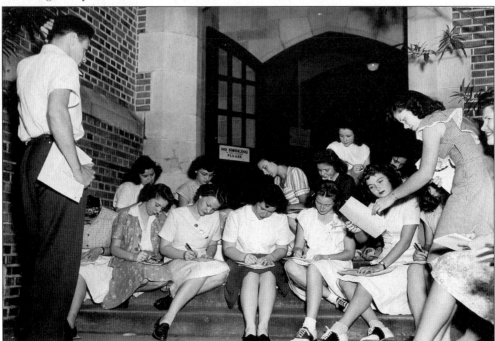

First Registration at University, Autumn 1947. State officials designated FSCW as the "Tallahassee Branch of the University of Florida" to allow men as well as women to attend. In 1947 the legislature renamed the institution Florida State University.

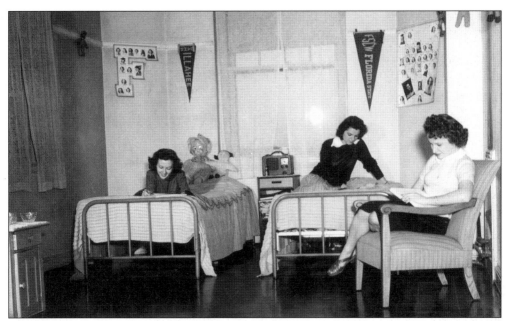

DORMITORY ROOM AT FSCW, 1946. Are girls really neater than boys? This Florida Department of Commerce photograph shows an amazingly tidy and well-kept space. It may be a real dorm room, or it may be the product of a lot of work to set up a scene that was meant to be ideal. Who knows what was left lying around outside the view of the camera's lens?

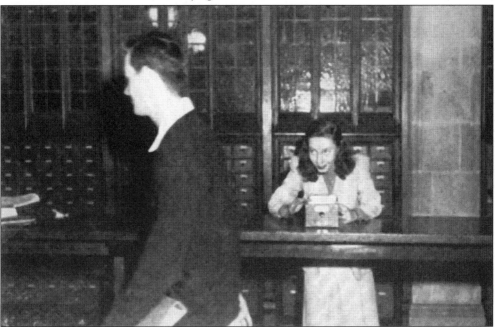

FSCW GOES CO-EDUCATIONAL, AUTUMN 1947. The scene is Dodd Hall, the college library. The action represents the first time in 42 years that men attended classes. World War II's end freed thousands of men from military service, and the G.I. Bill enabled many of them to pay for a college education. The Florida legislature responded by opening previously closed campuses and hiring new and experienced professors from all over the nation.

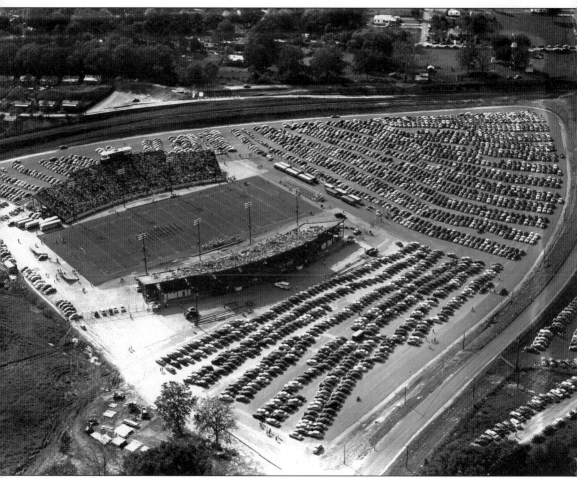

FLORIDA STATE UNIVERSITY (FSU) FOOTBALL STADIUM, OCTOBER 28, 1950. As Florida State expanded after World War II, the traditional autumn sport of football returned. A new stadium, later named after University President Doak Campbell (1941–1957), hosted this inaugural game, in which FSU triumphed over the University of the South with a score of 14-8. From the photograph it appears that parking was a problem right from the beginning.

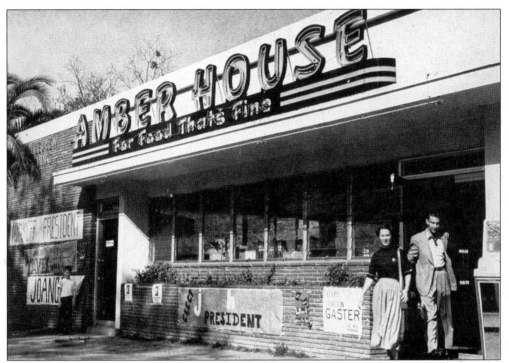

STUDENT HANGOUTS ON THE FSU CAMPUS, 1952. Just across the street and a block north of Westcott Hall stood a group of student hangouts: Amber House Restaurant, Malone's Co-op, and The Mecca. The Mecca lasted longest, only going out of business in 2001. Bill's Bookstore later occupied the Amber House building.

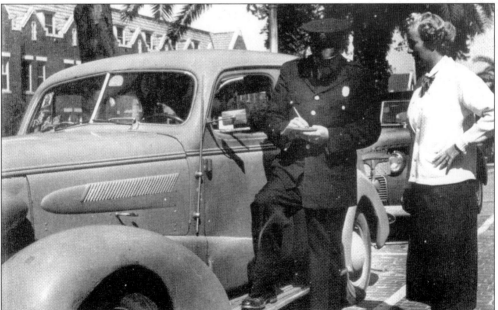

FSU POLICEMAN WRITING A PARKING TICKET, 1953. As many students since that time can attest, parking has always been a problem on campus. The author seems to recall something similar happening to him a few years ago.

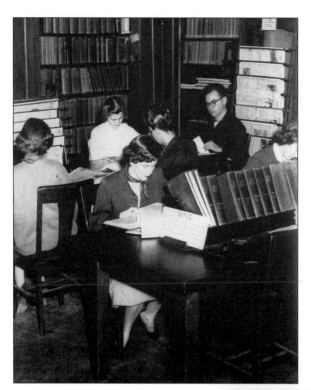

STUDENTS IN THE DODD HALL LIBRARY, 1952. Beautiful Dodd Hall started bursting at the seams with all the books, periodicals, government documents, maps, and microfilms needed for an ever-growing student population. Campus officials built Strozier Library in 1958. Strozier has been added to extensively over the years, and probably needs more room to grow even now.

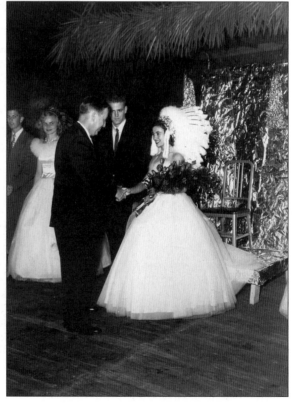

FSU HOMECOMING, 1953. Though the university football team was named for the Seminole Indians of Florida, no one at the university then realized that the Seminoles had their own very colorful and distinctive style of dress. So this homecoming queen wears a Northern Plains Indian feather bonnet. She is shaking hands with Florida Gov. Charley Johns.

DANCING AT THE FSU STUDENT UNION EVERY FRIDAY NIGHT, 1954. Here is a classic scene of swinging and jitterbugging. This was the year Elvis first came to the nation's attention. The King started the first rock-'n-roll riot at a Jacksonville concert two years later.

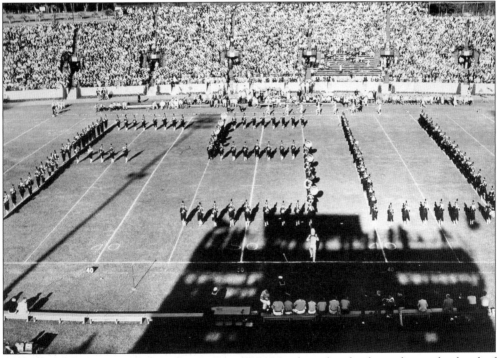

FSU MARCHING CHIEFS, HOMECOMING, 1955. Marching bands always boost the level of excitement at halftime. Seminole fans cheer in a five-year-old Doak Campbell Stadium, much smaller than the present complex.

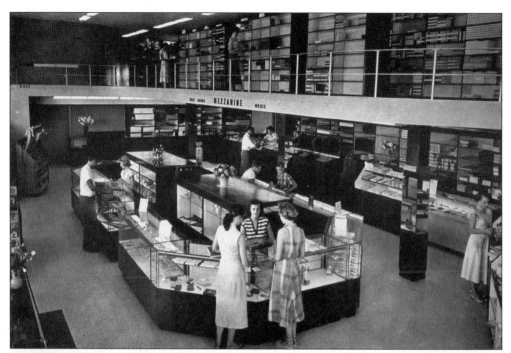

THE FSU UNIVERSITY UNION BOOK STORE, 1954. The start of every semester saw long lines of students buying books, supplies, and clothing for their new classes. This photograph must have been taken after the big rush.

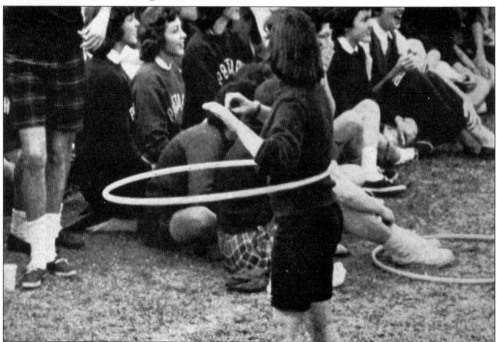

SIGMA CHI SORORITY STUDENTS PARTICIPATING IN A HOOLA HOOP CONTEST, 1959. The hoola hoop fad swept the nation for several years in the late 1950s and early 1960s. The fashion for this inexpensive toy has revived several times over the last 40 years.

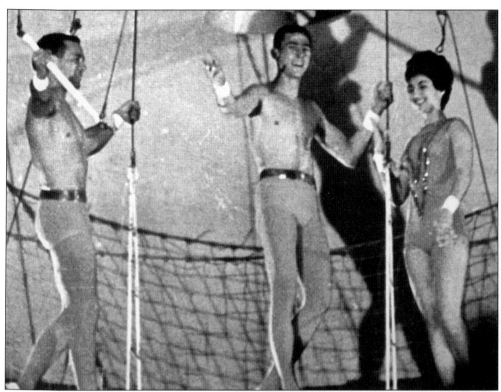

FSU's Flying High Circus, 1964.
A unique part of the university since 1947, the Flying High Circus takes student volunteers and trains them in the various gymnastic stunts that people commonly see at the circus. In recent years the student circus has traveled to Callaway Gardens in Georgia for summer performances.

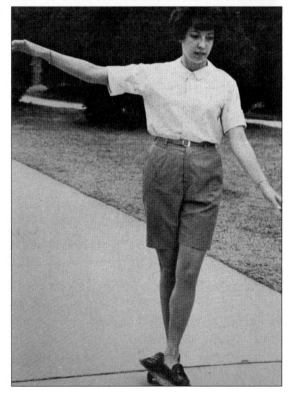

Student Skateboarding, 1965.
Though it started as a fad, skateboarding has endured and is now a recognized sport. The city of Tallahassee built a skate park for enthusiasts in 2001. This student, wearing a fashionable "peter pan" style collar, appears to be using the original version of the skateboard, a flat oval of wood with metal roller skate wheels. We've come a long way.

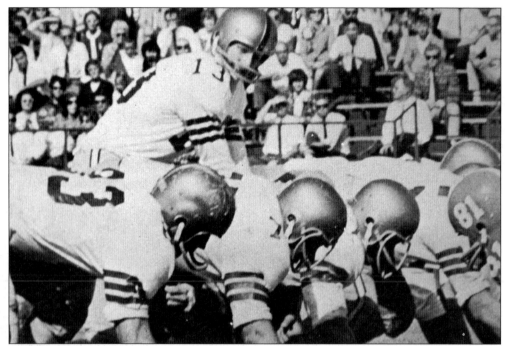

FLORIDA STATE VERSUS THE UNIVERSITY OF FLORIDA, FALL 1965. This photograph documents the first ever college football game between these two great rivals. The game, at Doak Campbell Stadium, ended with FSU besting its rival 16 to 7. The competition continues.

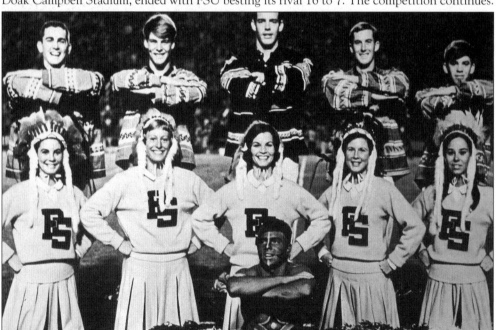

FSUS CHEERLEADING TEAM, 1968. The Seminole motif is just starting to move in the right direction. While the women still wear northern plains headdresses and the "chief" sitting cross-legged in front wears paint of no particular ethnicity, the young men in the background appear to be wearing traditional Seminole patchwork jackets.

72

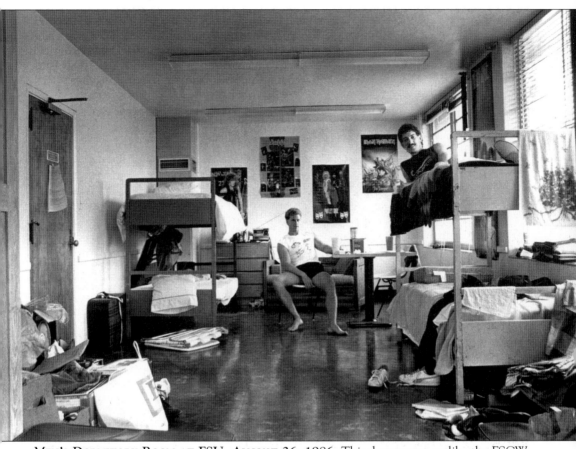

MEN'S DORMITORY ROOM AT FSU, AUGUST 26, 1986. This dorm room, unlike the FSCW room shown on an earlier page, appears more realistic. Or is it just a guy thing?

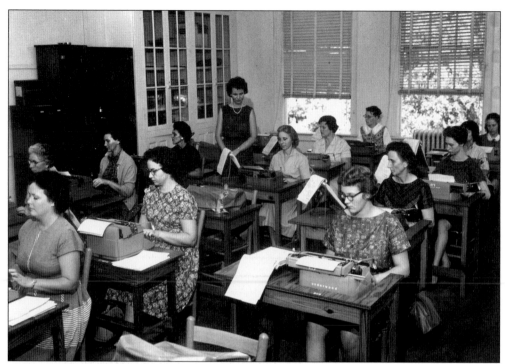

LIVELY VOCATIONAL CLASSROOM, C. 1957–1963. This institution was founded in 1931 in a business building owned by Lewis M. Lively. The photograph shows a room full of women practicing their typing skills. Unlike typewriters themselves, the skill of touch-typing remains important in today's business culture with computers and keyboards in every room. Students in the early years concentrated their efforts on typing, shorthand, bookkeeping, and accounting.

TALLAHASSEE COMMUNITY COLLEGE, 1980S. Tallahassee native and Florida governor LeRoy Collins helped create the community college system in Florida in the 1950s. TCC, which first opened in 1967, offers two-year programs that prepare students for professions such as nursing and data processing. It also affords students the opportunity to earn an A.A. degree and to move on to a four-year college for a bachelor's degree.

Four
CITY SCHOOLS

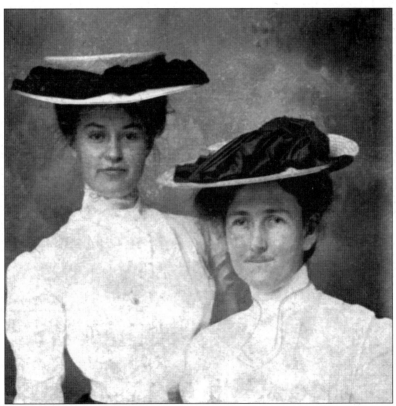

MATTIE SULLIVAN (LEFT) AND HER SISTER MISS KATE SULLIVAN (RIGHT), C. 1895–1905.
Kate Sullivan taught in Tallahassee elementary schools from 1901 until her retirement in 1948.
When the school district built a new grade school in 1949 they named it after her.

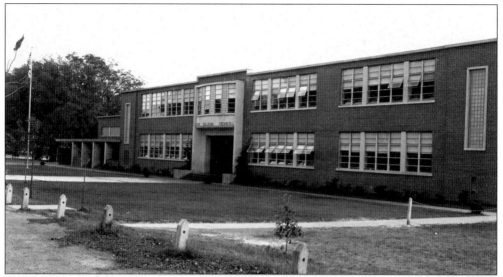

KATE SULLIVAN ELEMENTARY SCHOOL ON MICCOSUKEE ROAD, 1956. Sullivan looks much the same today as it did almost 40 years ago. The additions extend into the playground areas on either side of the original building. Artist John Birch placed a smiling crocodile in the front yard of the school in 1998 to represent the school mascot, the Kate Sullivan Crocodile.

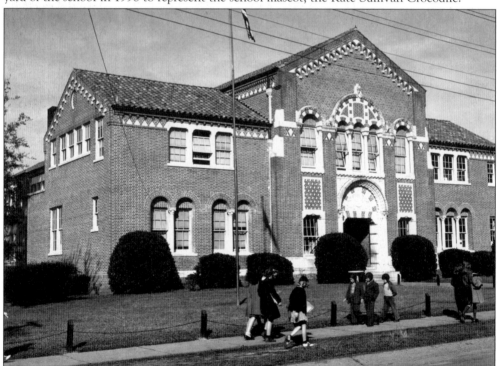

SEALEY ELEMENTARY SCHOOL ON CALHOUN STREET, 1946. This 1920s brick schoolhouse was an architectural gem. The facade features relief-carved plants and animals, decorative brick and stonework, and Spanish-style ceramic roof tiles. It was torn down in 1969. The State of Florida owns a similar style building, first built as the Caroline Brevard Elementary School, and now renamed the Bloxham Building. It is well worth a visit.

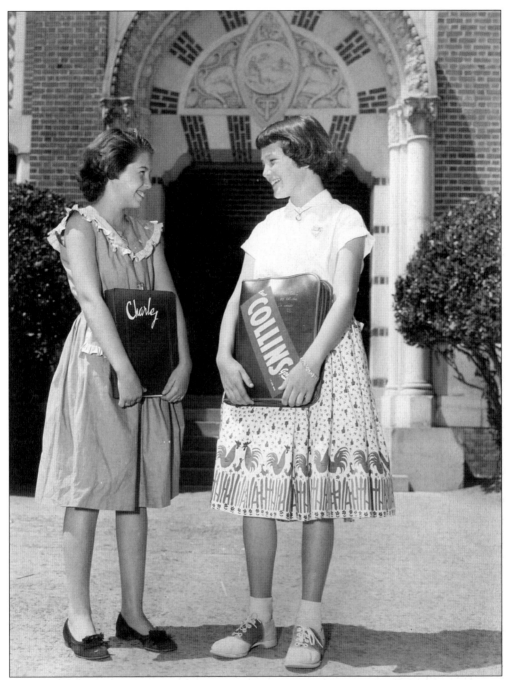

MARKLEYANN JOHNS AND MARY CALL COLLINS IN FRONT OF SEALEY ELEMENTARY, SPRING 1954. Both girls attended the same school and were good friends. Their fathers, however, were rivals, running for election to the highest office in the state—governor. On May 25, 1954 LeRoy Collins won the Democratic primary against Charley Johns. Both men worked together in Florida government, Johns as a state senator, Collins as governor.

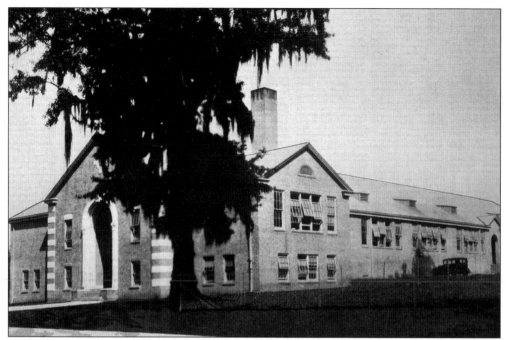

Lincoln High School, 1929. The secondary school for black children in Tallahassee started as Lincoln Academy in 1866 as part of Reconstruction after the Civil War. In 1929 the county built a new brick school on Brevard Street for them, as segregation continued in Leon County and the South until the 1960s and 1970s.

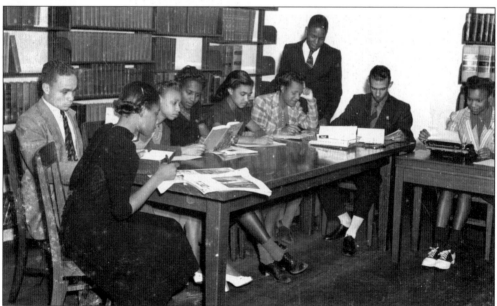

Lincoln High Students in the Library, c. 1946–1950. Though they learned under a segregated school system at the time this photograph was taken, the students did have opportunities for higher education at Florida A&M College as well as other, out-of-state colleges. A new Lincoln High School in a new location is a vital part of Tallahassee's secondary education system.

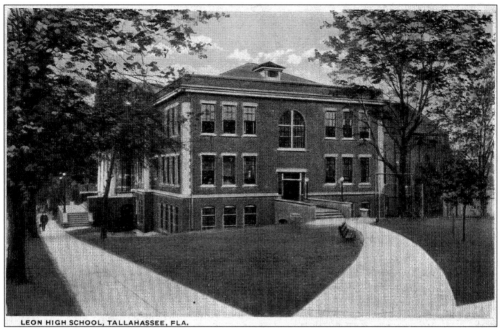

LEON HIGH SCHOOL, TALLAHASSEE, FLA.

LEON HIGH SCHOOL, C. 1920–1925. The city built this school in 1910 on the north side of Park Avenue between Duval and Bronough Streets. When students moved to a new building on Tennessee Street in 1937, Lively Technical Center moved into this building. In the 1960s the old building was torn down. Twenty years later city fathers broke ground for the LeRoy Collins Leon County Public Library on this site, which opened in 1993.

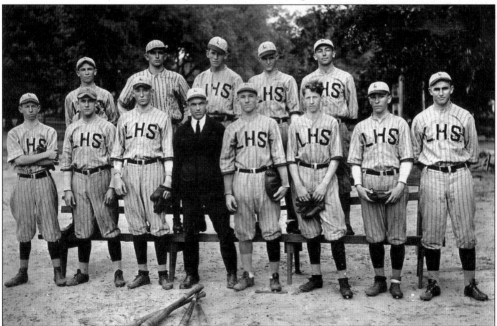

THE 1922 LEON HIGH SCHOOL BASEBALL TEAM. These teenagers give the impression that they are trying to look at least 10 years older than they are. The coach, Mr. Lee Work, is the one in coat and tie.

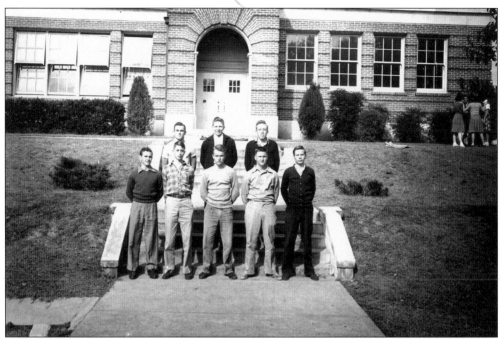

LEON HIGH SCHOOL STUDENTS, NOVEMBER 28, 1944. These young men with serious demeanors, standing at the east side entrance to the new school, may soon be graduating and likely joining the military. American participation in World War II had been raging for three years when this photograph was made, with no end yet in sight. They had a lot to think about.

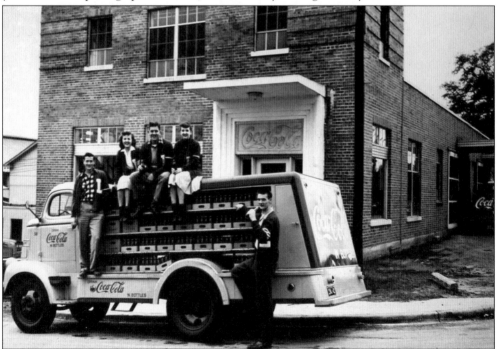

COCA-COLA BOTTLING PLANT AND DELIVERY TRUCK, 1948. Three years after the end of the war, these Leon High students appear to be in a more easygoing frame of mind.

Five

NATURAL ATTRACTIONS

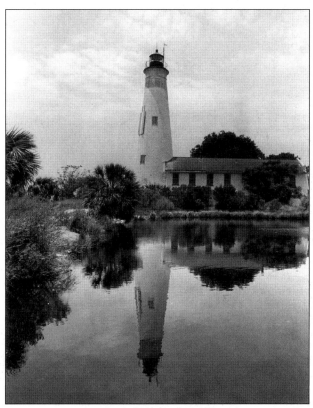

ST. MARK'S LIGHTHOUSE, 1970S. The lighthouse stands as the centerpiece of the St. Mark's Wildlife Refuge on the shores of the Gulf of Mexico. Built in 1831 from limestone blocks, some of which may have been taken from an old Spanish fort near the site, the lighthouse saw United States Navy landings and damage during the Civil War coastal blockade of the Confederacy. The area is a migratory bird flyway stopover in spring and autumn.

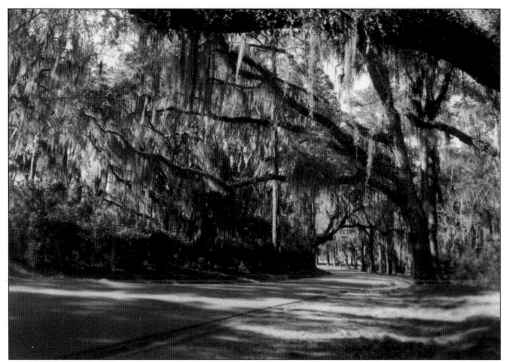

CANOPY ROAD NEAR MYERS PARK, 1971. Though many Tallahasseans take great pride in their city's tree-lined roads, many, if not most of these shady lanes only started growing into canopies in the 1930s and 1940s. This particular canopy remains a beautiful and picturesque view. The Myers Park tennis courts lie just beyond the turn in the road.

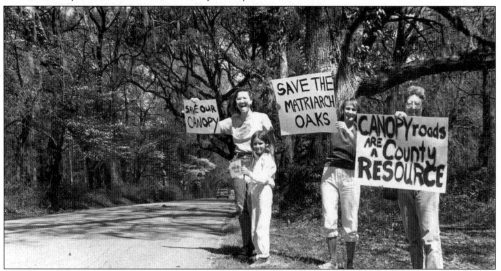

DEMONSTRATORS ALONG A CANOPY ROAD, MARCH 24, 1985. The struggle between conservation of resources and development is not a long one in Florida or Tallahassee. Only since the 1970s have conservation-minded people won any significant victories. These people hold up signs pointing out the clear relationship between the value and attractiveness of a canopy road for all citizens versus the considerable profits that a few individuals reap from bulldozing the landscape.

ALFRED B. MACLAY HOUSE IN 1925. This winter home of a New York financier and his wife, Louise Fleischmann Maclay, became the center point of a major landscape garden in the 1930s to the 1950s. Mrs. Maclay deeded the home and gardens, located directly off Thomasville Road, to the people of Florida in 1953. The state named it Killearn Gardens, then in 1965 it was renamed the Alfred B. Maclay State Gardens.

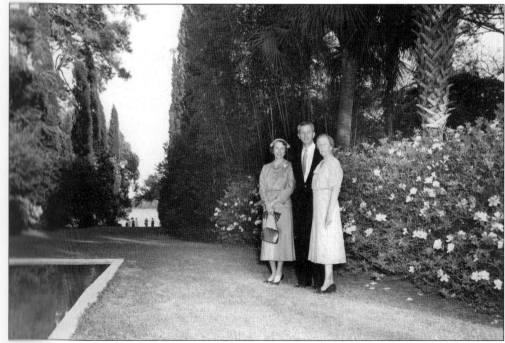

TARZAN'S SECRET TREASURE, JUNE AND JULY brings made it an ideal place to film underwater adventure movies. Young Ernest was a "stand-in" ny Weismueller, "Tarzan," was here, too.

FIRST LADY MARY CALL COLLINS (LEFT), GOV. LEROY COLLINS (CENTER), AND LOUISE FLEISHMANN MACLAY (RIGHT), MARCH 13, 1955. These three people stand along a beautiful blossoming azalea hedge in Maclay Gardens. A small glimpse of Lake Hall appears on the left at the end of the avenue of poplars.

TALLAHASSEE MUSEUM OF HISTORY AND NATURAL SCIENCE, C. 1985. This beautiful outdoor museum, until May 1992 known as the Junior Museum, emphasizes both the local ecology and Tallahassee's colorful history. A large habitat zoo includes boardwalks through cypress groves where visitors can observe river otters, guest animals, rare Florida panthers, and the no-longer-endangered alligator.

ERNEST DAFFIN DURING THE FILMING O
1941. The crystal clear waters of Wakulla
location sequences in a number of Hollywoo
for the character "Boy" in a Tarzan film. Jo

Six

CULTURAL ATTRACTIONS

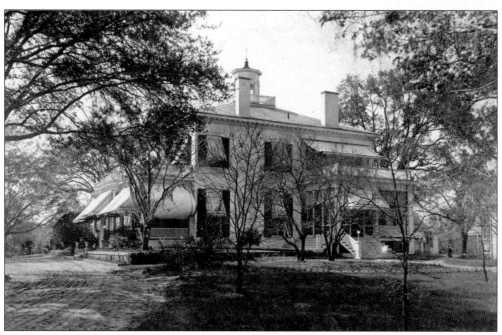

GOODWOOD MANSION, PHOTOGRAPHED IN 1919. Begun in the 1830s by North Carolina planter Hardy Croom and finished in 1840 by Bryan Croom after Hardy's death in a steamboat sinking, this restored home was one of the grandest in antebellum Tallahassee. It boasted painted and sculptured ceilings, marble, tall pier mirrors, and glass.

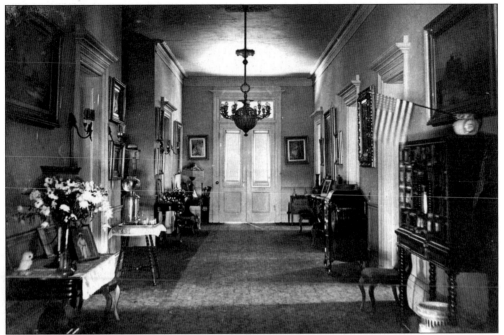

ENTRANCE HALLWAY, GOODWOOD MANSION, PHOTOGRAPHED IN 1919. Later owners of the mansion and plantation added and remodeled to an extent and put in electric utilities and different furniture. However, the character of the house has been remarkably retained throughout the years.

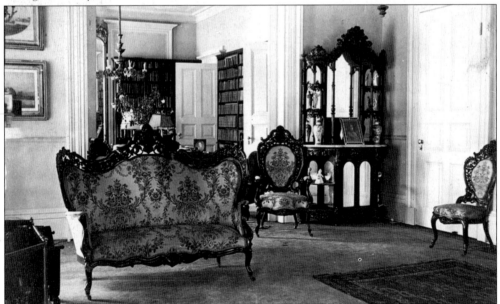

PARLOR, GOODWOOD MANSION, 1919. The background of this photograph gives a glimpse of the magnificent sculptured and painted ceilings and one of the huge pier mirrors that graced the mansion. In the 1990s curator Larry Paarlberg painstakingly restored and directed other experts in fully restoring both the mansion house and the surrounding gardens and guest houses. Today the estate is known as Goodwood Museum and Gardens.

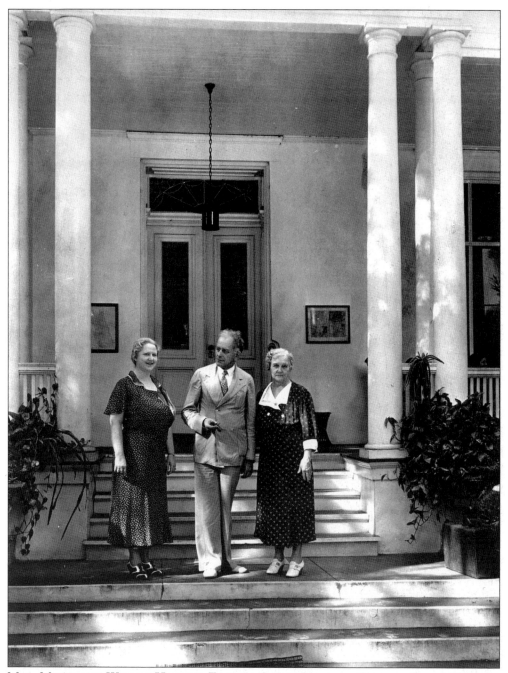

MRS. MARGARET WILSON HODGES, FLORIDA STATE SENATOR WILLIAM CABOT HODGES, AND HIS SISTER EVA HODGES AT GOODWOOD MANSION, C. 1930–1935. Senator Hodges was one of the more colorful owners of the historic plantation home. He entertained lavishly, partly to enhance his standing in the state Senate, and kept up the house in a grand manner. He is famous in state history for having instigated the $25,000 Homestead Exemption amendment to the Florida constitution, which continues to aid Florida homeowners to this day.

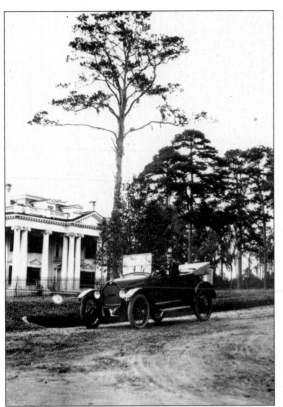

SENATOR WILLIAM CABOT HODGES IN FRONT OF THE GOVERNOR'S MANSION, C. 1918–1920. As one of the state's most prominent politicians, it would not have been uncommon for the senator to drive over to the mansion to confer with the governor and other state leaders. In the background is the first Governor's Mansion, built in 1906. The streets weren't paved this far out of town for a number of years.

ENTRANCE HALL OF THE OLD GOVERNOR'S MANSION, 1952. The mansion butler, Mr. Martin Van Buren Tanner, held his job at the governor's home from 1925 until he retired in the mid-1950s. The second floor held the private family rooms, while architects laid out the first floor to enable large numbers of visitors and meetings to take place. The state legislature spent so little money on the mansion's upkeep that Gov. Fuller Warren (served 1949–1953) called the place "a shack."

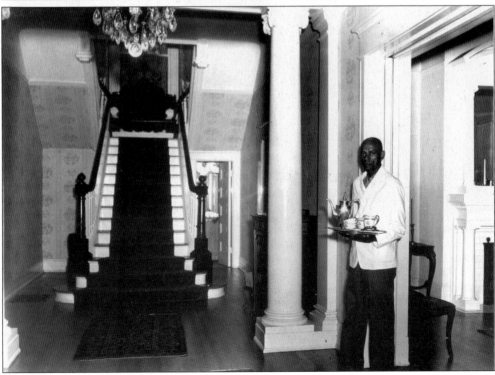

GOV. DANIEL THOMAS MCCARTY ON THE FRONT PORCH OF THE OLD GOVERNOR'S MANSION, FEBRUARY 1953. He may be the governor of Florida but his kids, like most kids, still leave their toys on the front porch (and probably in the front yard as well). Governor McCarty died later that year of a heart attack. Gov. LeRoy Collins, his close friend and associate, carried his progressive reform program on two years later.

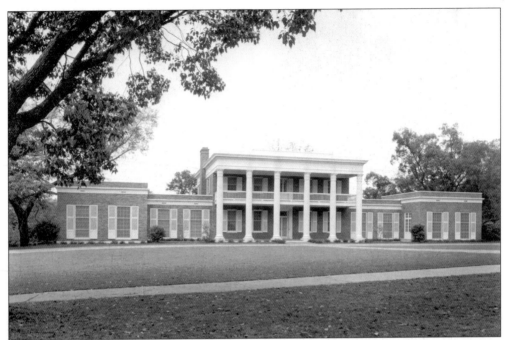

THE NEW GOVERNOR'S MANSION, APRIL 12, 1957. Security was not much of a concern then. Gov. LeRoy Collins often walked from the mansion down to his office in the capitol building, stopping at stores along the way to visit with lifelong friends and political associates. Tearing down the old mansion was easy for Governor Collins as he lived in "The Grove," on the estate next door to the Governor's Mansion.

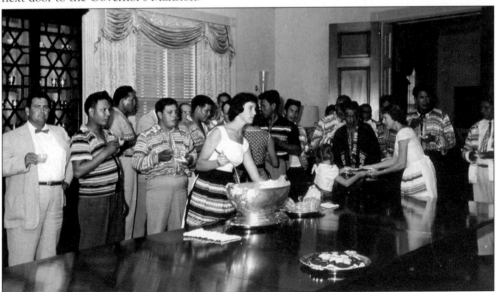

GOV. LEROY COLLINS ENTERTAINING SEMINOLE INDIAN LEADERS AT THE GOVERNOR'S MANSION, 1956. On special occasions, such as this, the governor brought out the historic Battleship Florida silver service from 1911. In this photograph, the second punch bowl, with eagle head handles is in use. The great punch bowl, with brown pelican handles, is on public view in the mansion when the public areas of the building are open.

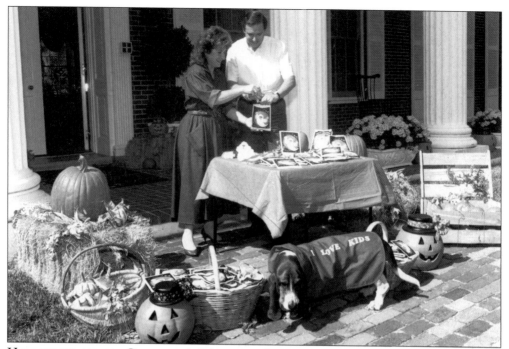

HALLOWEEN AT THE GOVERNOR'S MANSION, OCTOBER 1987. Gov. Bob Martinez and his wife Mary Jane Martinez, with their family dog, Tampa Mascotte, get ready for trick-or-treaters at the front door of the mansion. Most governors in the late 20th century have worked hard to have a real family life while they occupied the Governor's Mansion. The Martinez family was popular in the neighborhood as well as around the state.

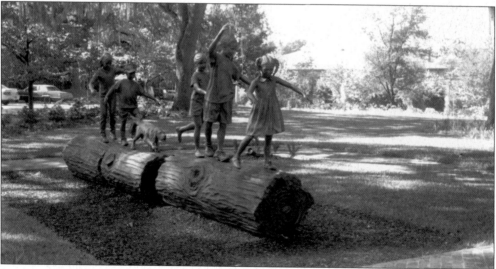

SCULPTURE IN THE PARK IN FRONT OF THE GOVERNOR'S MANSION, 1998. Artist Stanley Proctor worked on a personal commission from Gov. Lawton Chiles and his wife Rhea Chiles to portray Florida children and their dog playing on a fallen tree trunk. Proctor titled the life-sized bronze casts "Florida's Finest." This public park is tucked away from the hustle of Monroe Street on a quiet lot directly in front of the mansion. Governor Chiles put Florida's children at the top of his legislative priority list.

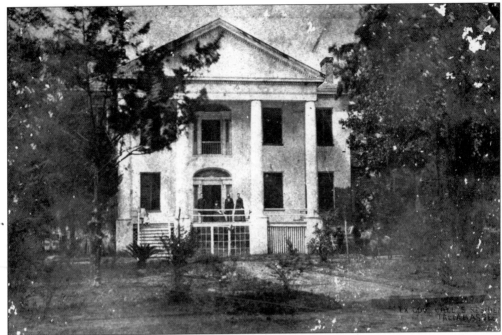

TERRITORIAL GOV. R.K. CALL'S ANTEBELLUM PLANTATION HOUSE, "THE GROVE," PHOTOGRAPHED IN 1874. Built in the 1830s, Richard Keith Call served as an officer in the Seminole Wars, as Territory governor, and as a major landowner in the cotton culture of Florida before the Civil War. Ellen Call Long, the governor's daughter, is seated in the center of the group on the porch.

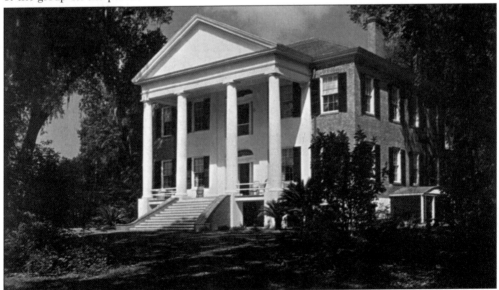

THE GROVE, POSTCARD C. 1960. This antebellum mansion sits next door to the Governor's Mansion. When state officials built the new Governor's Mansion in 1956–1957, Gov. LeRoy Collins and his wife Mary Call Collins, a direct descendant of Territory governor Richard Keith Call, just moved next door to their family home for two years. Governor and Mrs. Collins have designated The Grove to be a state historic site to be open to the public at a future date.

WILLIAM VALENTINE KNOTT ON HIS 100TH BIRTHDAY AND HIS WIFE LUELLA PUGH KNOTT, NOVEMBER 20, 1963. W.V. Knott, longtime leader in state politics and his wife, a leader of the temperance movement in Florida, stand on the front porch of the Knott House, now a state historic site. The Knott House Museum is open to the public. The house contains the Knott's furniture and belongings, including the poems Luella wrote about her furniture, among many other things.

W.V. KNOTT HOUSE, C. 1960–1965. Built in 1839–1842, Union Brig. Gen. Edward McCook used the house as his headquarters after the end of the Civil War, and announced President Abraham Lincoln's Emancipation Proclamation from there on May 20, 1865. To this day the black community in Tallahassee celebrates Emancipation Day on that day, when an annual re-enactment of the event takes place.

LeMoyne Art Center Director Dick Puckett, May 22, 1970. Mr. Puckett prepares mats for display of art works. Named after the French artist who accompanied one of the earliest groups of settlers in Florida in 1564–1565, the art center offers both an education center offering art classes and a sculpture garden for community events.

The Challenger Learning Center, April 2003. A new space science and I-Max Movie center opened in March 2003. Dedicated by space shuttle astronaut Dr. Norm Thagard of Florida State University, the learning center promises to bring Tallahassee students into the 21st century. Next door to the Challenger Center stands the Mary Brogan Art and Science Center. Since 1995 it has brought both science and art exhibits for children and adults to Tallahassee. (Author's collection.)

THE R.A. GRAY BUILDING, 2002. The preservation and historical center of state government, the Gray Building houses the State Library, State Archives, State Photographic Archives, State History Museum, Historic Preservation Program, State Archaeology Program, and includes an underwater artifact conservation laboratory. Changing exhibits, new books, and resources for genealogists make this building the one-stop shop for historical and cultural resources.

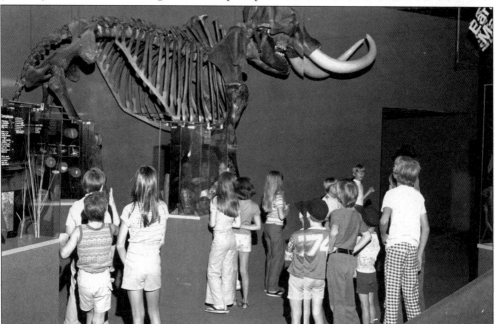

"HERMAN" THE MUSEUM MASTODON SKELETON, PHOTOGRAPHED IN 1977. Retrieved from Wakulla Springs in August 1930, this nearly complete skeleton of a 12,000-year-old extinct mastodon serves as an unofficial "mascot" of the Museum of Florida History. Over 150,000 children and adults visit the museum every year.

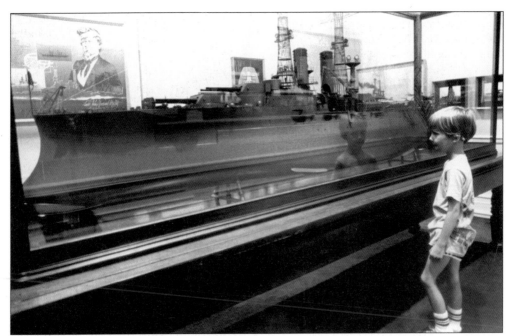

MUSEUM OF FLORIDA HISTORY, MODEL OF THE 1911 BATTLESHIP USS *FLORIDA*, PHOTOGRAPHED 1983. The museum houses exhibits and collections relating to Florida's colorful past from prehistoric Indians to Spanish gold, 19th-century steamboats, and a special exhibit about Florida's role in World War II.

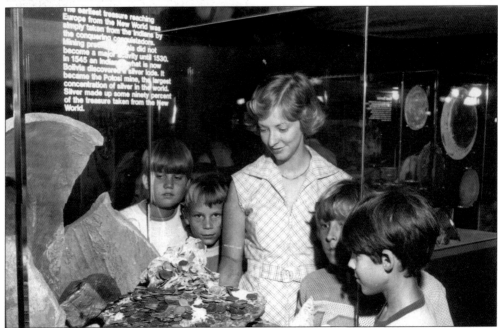

SPANISH SILVER FROM THE BUREAU OF ARCHAEOLOGICAL RESEARCH, MUSEUM OF FLORIDA HISTORY, PHOTOGRAPHED IN 1977. Archaeologists and treasure hunters search Florida's coasts for the wrecks of Spanish ships from the 16th, 17th, and 18th centuries. Selected treasures found, collected, and preserved over the years are exhibited in the Museum Gallery.

**Flag Displayed from the Old Capitol,
September 21, 2001.** This giant flag
commemorated the victims of the terrorist
attack on September 11. The old capitol
has become the "jewel of the capitol
complex," with new exhibits on Florida
political history and frequent use during
inaugurations and ceremonial state
occasions. Archives photographer Wayne
Denmark took this photograph.

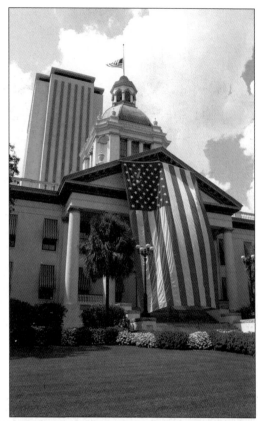

**The 22nd Floor Observation Deck of
the New Capitol, Photographed in
1989.** As the highest point in Tallahassee,
on a clear day visitors can see the St. Marks
lighthouse to the south. Since the terrorist
attack of September 11, 2001, the capitol is
only open to visitors Monday through
Friday from 8 a.m. to 5 p.m.

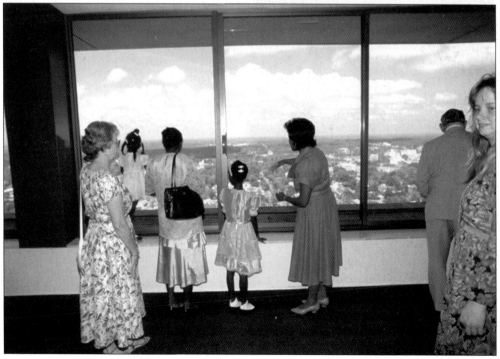

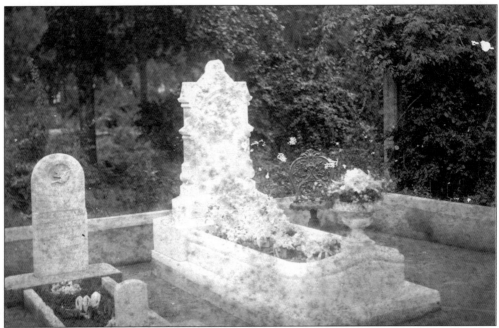

TALLAHASSEE OLD CITY CEMETERY, PERKINS FAMILY PLOT, C. 1880–1890. Founded in the 1820s, officially laid out after the Yellow Fever epidemic of June 1841, and site of both Union and Confederate soldier and veteran graves, this is one of the most historic cemeteries in the state. It is cared for by both the City of Tallahassee and a Friends of the Old City Cemetery volunteer group, who both clean the graves and research the history of Tallahassee through the cemetery's history.

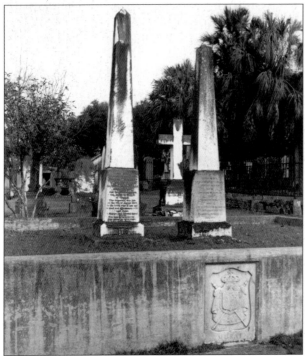

GRAVES OF PRINCE AND PRINCESS MURAT, PHOTOGRAPHED ON MARCH 10, 1949. Across the street from the Old City Cemetery is the St. John's Episcopal burying ground. Prince Murat, nephew of French Emperor Napoleon Bonaparte, fled to America after the fall of Napoleon, rebuilding his fortunes by marrying heiresses. He died in 1847 and his last wife, Tallahassean Catherine Gray, died in 1867. Both are buried under these marble obelisks. Also buried here are a Confederate general, State Supreme Court Justices, and other leaders of the Tallahassee community in the 19th century.

GREENWOOD CEMETERY, WILLIE L. GALIMORE GRAVE, PHOTOGRAPHED APRIL 2003. Galimore became a football star at Florida A&M College in the 1950s under the leadership of coach Jake Gaither. He later became one of the stars of the National Football League championship Chicago Bears team from 1957 to 1963. Galimore was reputedly the best football player Coach Gaither ever taught. (Author's collection.)

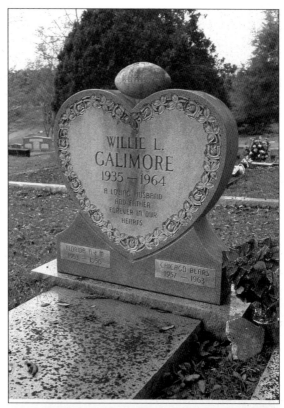

GALIMORE GRAVE, DETAIL OF CARVED FOOTBALL. Greenwood Cemetery started in 1937 when Tallahassee City Council members denied black Tallahasseans access to city burying grounds. The cemetery, on Old Bainbridge Road, is a testament to the hardships of segregation. A new community spirit moved black and white Tallahasseans, led by cemetery expert Sharyn Thompson, to restore the burying ground in the 1990s. (Author's collection.)

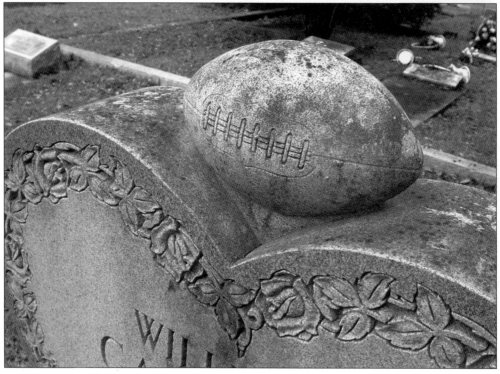

RILEY HOUSE MUSEUM, 419 EAST JEFFERSON AVENUE, PHOTOGRAPHED 1999. Built in the 1890s for Lincoln High School principal John Gillmore Riley, the house has survived numerous urban renewal projects. Mr. Riley was a leader in the black community in the first half of the 20th century. Today the restored home serves as both a museum and black cultural center under the direction of Althemese Barnes.

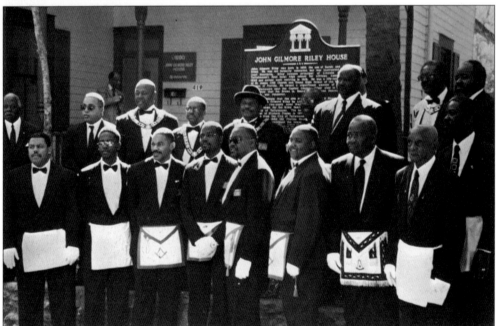

DEDICATION OF THE RILEY HOUSE MUSEUM HISTORIC MARKER, FEBRUARY 1998. Mr. Riley served as the statewide master of the black chapters of the Free and Accepted Masons fraternal order in the early 20th century. This gathering of contemporary leaders of the Masonic Order marks the honoring of one of their own past leaders as a recognized historic figure.

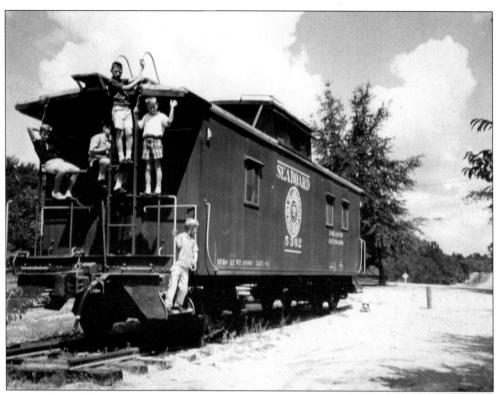

TALLAHASSEE MUSEUM OF HISTORY AND NATURAL SCIENCE, PHOTOGRAPHED AUGUST 1965. The historical areas of the museum contain important structures and artifacts from Tallahassee's past, including this caboose from the Seaboard Airline Railroad, the home of Princess Catherine Murat, and other historic buildings. Changing exhibits have told of Tallahassee's past from funeral customs in the 19th century to the capital city's role in World War II.

MISSION SAN LUIS ARCHAEOLOGICAL SITE, APALACHEE INDIAN COUNCIL HOUSE, PHOTOGRAPHED 2001. From 1656 to 1704, during the Spanish domination of Florida, San Luis served as the capital of the Catholic mission system throughout northwest Florida. State archaeologists have excavated extensively at the site and have guided the recreation of the Spanish and Apalachee Indian village, including the mission church, Chief's House, and Apalachee Council House. A living history program re-enacts daily life in 17th-century Tallahassee. (Author's collection.)

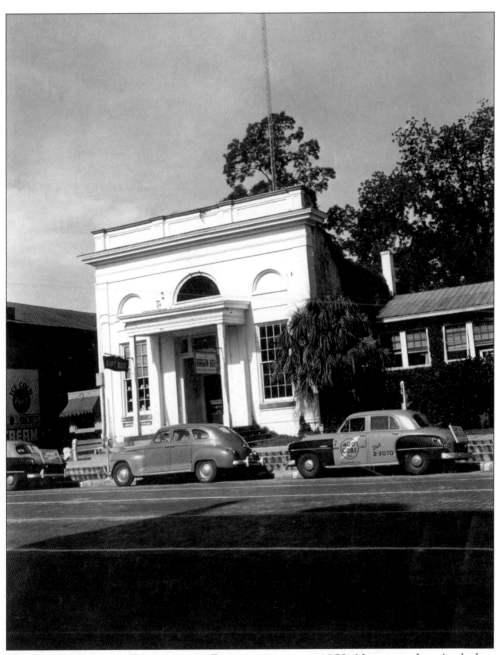

THE UNION BANK OF TALLAHASSEE, PHOTOGRAPHED IN 1952. Now moved to Apalachee Parkway, directly across from the old capitol, this historic 1841 building is the earliest remaining banking structure in the state. Constructing the building contributed to the bankruptcy of the Union Bank in 1843. After the Civil War it served as a Freedman's Bank, then housed a variety of businesses, including the black-owned Jiles Shoe Factory. Today the Florida A&M Black Archives, Museum, and Research Center operates a fascinating historical program in the old structure.

Seven

RELIGION

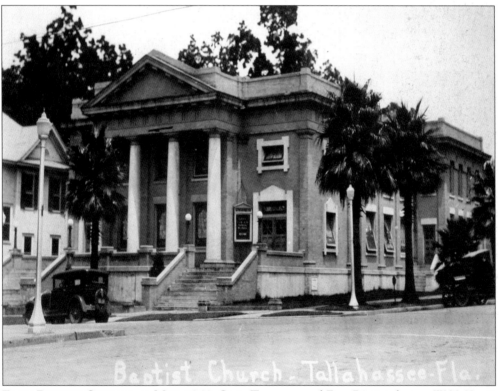

FIRST BAPTIST CHURCH, C. MAY 1949. State Treasurer and First Baptist deacon W.V. Knott secured a large lot on College Avenue and Adams Street in 1911. The congregation began worshiping in their new building in November 1915. By 1946 they felt a need for more space and the building in this photograph resulted. A new and much larger church and Christian Activity Center now occupy the block.

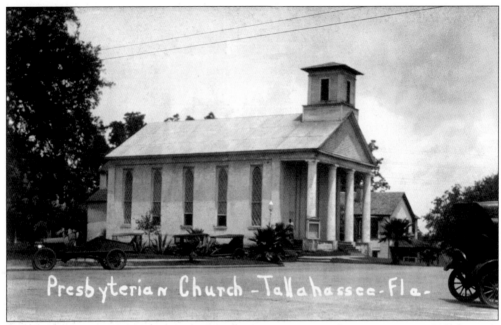

Presbyterian Church -Tallahassee-Fla.

FIRST PRESBYTERIAN CHURCH, PHOTOGRAPHED IN 1929. The congregation, Tallahassee's first organized religious body, formed in 1832. They secured a property on the edge of town at the end of McCarty Street, now Park Avenue, in 1835 and finally started worshiping in the building during the spring of 1838.

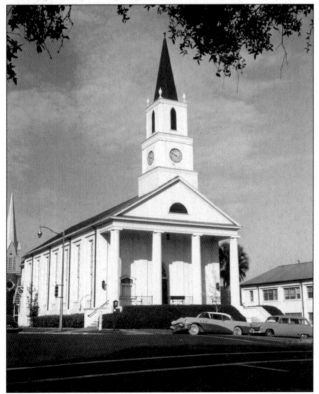

FIRST PRESBYTERIAN CHURCH, PHOTOGRAPHED IN 1957. Unlike all the other churches in Tallahassee's early history, this congregation retains its original building. It has been somewhat remodeled, with a steeple echoing that of Trinity Methodist at the other end of the block. This is one of the oldest public buildings in the state still being used for its original purpose.

St John's Episcopal Church, Photographed c. 1885–1890.
Built on the site of an earlier structure in 1880–1881, this building displays a strong Gothic Revival style that remains clearly evident to this day. The obelisks at the Monroe Street front memorialize congregation members Hardy Croom and his family who drowned in a shipwreck off the coast of North Carolina in 1837 and the Rev. J.L. Woart and his wife Elizabeth "who perished in the wreck of the *Pulaski*, June 18, 1838."

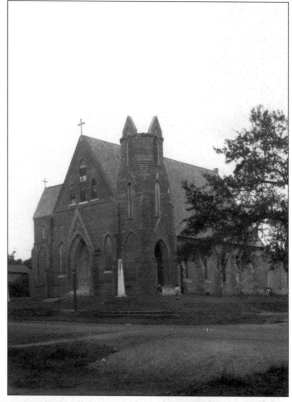

St. John's Episcopal Church, Photographed in 1948. This side view of the church includes the parson's house to the right of the picture, built in 1839–1840 and remodeled extensively over time.

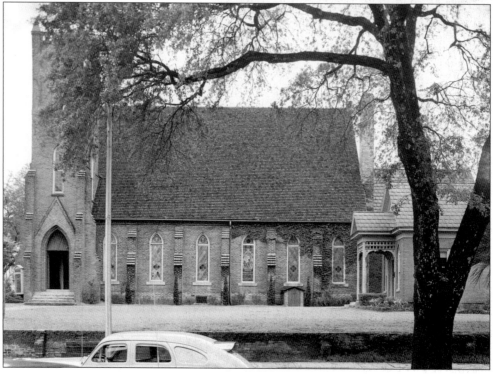

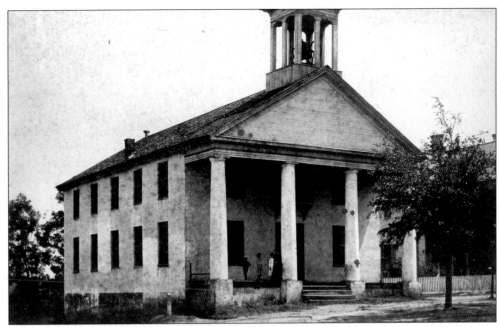

TRINITY METHODIST CHURCH, PHOTOGRAPHED BEFORE 1892. The Methodists, like the Presbyterians before them, chose a Greek Revival–style church. Members of the local Masonic Order laid the cornerstone on May 4, 1840. At that time men sat on movable benches on one side of the sanctuary; women sat on the other.

TRINITY METHODIST CHURCH, C. 1893–1900. Built on the same lot after demolition of the first church, this larger structure showed off the fashionable Gothic Revival style. Next to the brick church stands the 1860 parson's house, resplendent in Victorian gingerbread ornament.

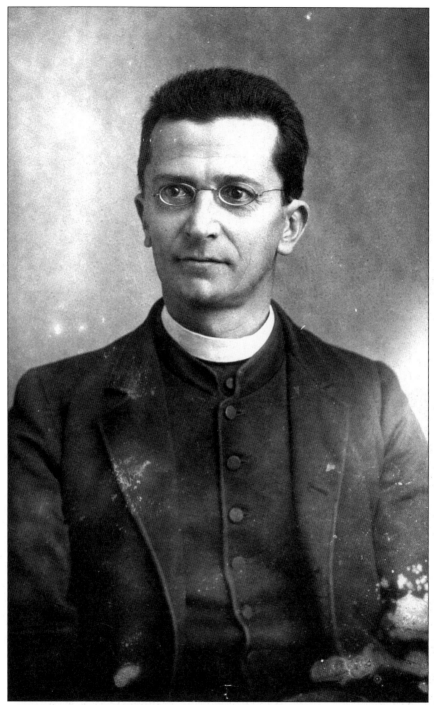

FR. JOSEPH HUGON, C. 1885–1890. Tallahassee's longest-serving Catholic priest in the 19th century, Father Hugon sat for this portrait at Alvan Harper's studio on South Monroe Street. He guided the city's growing Catholic congregation from his arrival in 1877 until his death 35 years later in 1912. Born in France, he had moved to America by 1866. The Tallahassee Knights of Columbus care for his monument in the Old City Cemetery to this day.

BLESSED SACRAMENT CATHOLIC CHURCH, PHOTOGRAPHED IN 1952. Built in 1892, the church stood at 440 North Monroe. Building a congregation in Tallahassee was the life work of Father Joseph Hugon. The congregation now worships in a newer church along Miccosukee Road near Kate Sullivan Elementary School.

HOLY MOTHER OF GOD GREEK ORTHODOX CHURCH, PHOTOGRAPHED IN THE LATE 1960S. Tallahassee's Greek community started in 1925 with the arrival of John Camechis, from the Isle of Patmos. But it was only in 1962 that enough Greek Orthodox believers lived in Tallahassee to form a congregation, and it was 1965 by the time a building for the congregation was built. The congregation, under the leadership of Rev. George Vaporis (served 1977–1983), began a tradition of fund-raising by holding a traditional Greek food and dance festival that continues to this day.

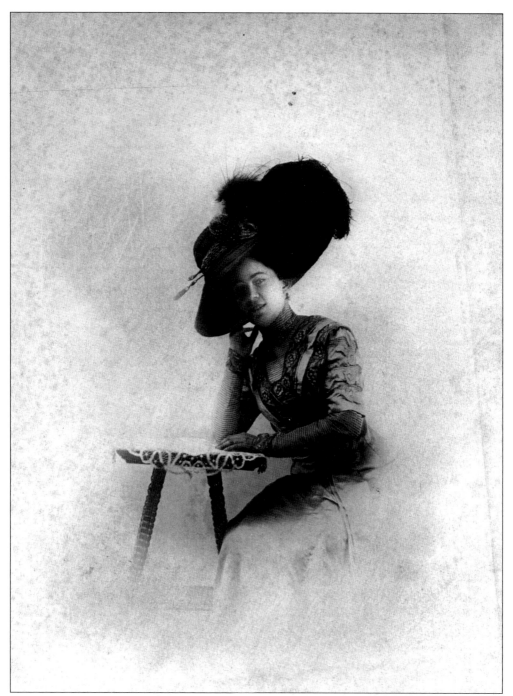

PORTRAIT OF MISS RUBY PEARL DIAMOND, 1910. The 24-year-old Tallahassee native shows off her Duchess of Devonshire hat and dress, the height of fashion. Her parents were among the earliest Jewish citizens of Tallahassee. After her parents died, she lived in city hotels, including the Leon, the Floridan, and the Hilton. She used her considerable wealth to benefit Florida State College for Women (she graduated from there in 1905) and later Florida State University, as well as her congregation, Temple Israel, and the community in general.

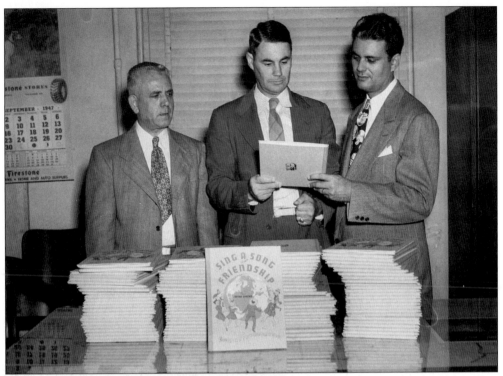

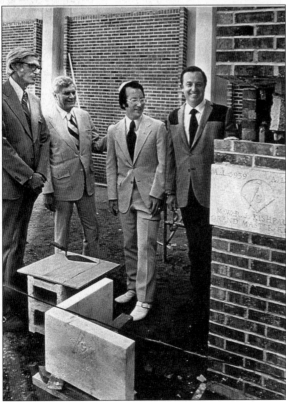

TEMPLE ISRAEL LEADERS PRESENTING A DONATION OF BOOKS, SEPTEMBER 1947. Julius Trushin (left) and Albert Block (right) present a set of songbooks to Leon County School Superintendent Amos Godby (center). Tallahassee's first Jewish congregation organized in 1937. They have always contributed to the Tallahassee community. In 1989, the City of Tallahassee recognized Temple's contributions by declaring a "Temple Israel Day." (Courtesy Rabbi Stanley Garfein.)

DEDICATION OF THE NEW TEMPLE ISRAEL SYNAGOGUE, 1972. Pictured, left to right, are Temple officers David Hirsch and Albert Block, Rabbi Stanley Garfein (who served the congregation from 1967 until his retirement at the end of 2001), and Florida Secretary of State Richard Stone. (Courtesy Rabbi Stanley Garfein.)

Eight
THROUGH SOME EVENTFUL YEARS

TALLAHASSEE PHOTOGRAPHER ALVAN HARPER ON ASSIGNMENT, C. 1900–1910. Mr. Harper deserves great credit for documenting many of early Tallahassee's people, places, and events. After his death, his photographs were put into storage and forgotten. In the 1970s, they were rediscovered, restored, and donated to the state photographic archives. A number of his distinctive glass-plate images appear in this book.

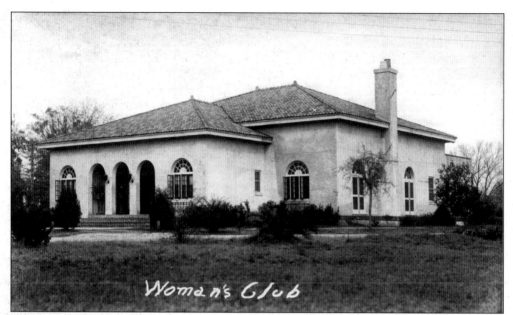

Woman's Club

TALLAHASSEE WOMAN'S CLUB BUILDING, PHOTOGRAPHED IN 1929. Built in 1924 at the height of the Mediterranean Revival craze going on in Coral Gables and Miami Beach, the club house was, and remains, the centerpiece of the Los Robles neighborhood. Tallahassee club members, and women's clubs statewide, lobbied (even before women were allowed the vote in 1920) to create a state park system in Florida. Royal Palm State Park, dedicated in 1916, was their first success. It is now the Everglades National Park.

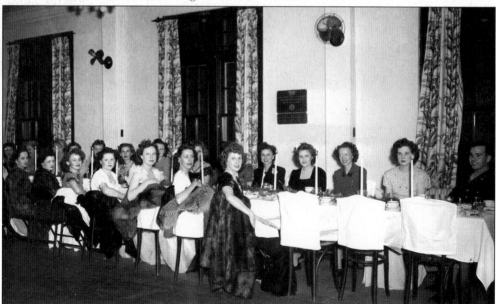

TALLAHASSEE JUNIOR WOMAN'S CLUB MEETING, DECEMBER 1944. The Woman's Club and the Junior Woman's Club continue to hold their monthly meetings at the Los Robles building, listed since 1972 on the National Register of Historic Places. The clubs organized aid to military service members during World War II and in all of America's conflicts, including Operation Iraqi Freedom in 2003.

114

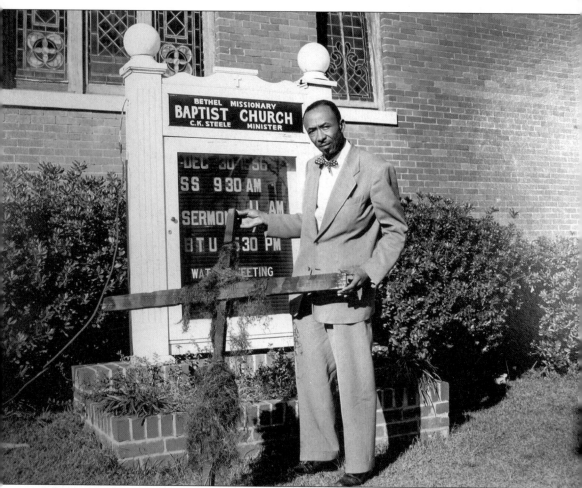

REV. C.K. STEELE DISPLAYS A BURNED CROSS, JANUARY 3, 1957. The pastor of Bethel Missionary Baptist Church led the nine-month-long Tallahassee Bus Boycott. The effort ended segregated seating on city busses. This cross burning at a black church was intended to scare the minister and the boycotters. It didn't.

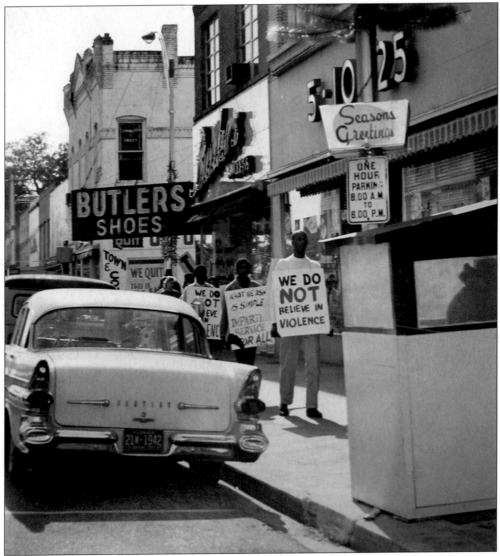

CIVIL RIGHTS PICKETS, MONROE STREET, DECEMBER 6, 1960. This demonstration took place because of the lack of progress in desegregating the downtown lunch counters at Neisner's, McCrory's, Woolworths, Walgreens, and Sears. Nonviolent attempts to integrate these public accommodations began in 1956. Major change only started to happen after the national Civil Rights Act of 1964.

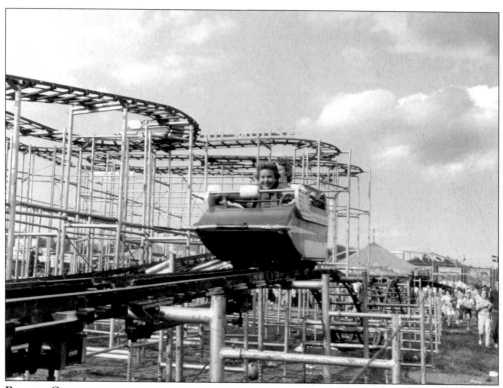

ROLLER COASTER AT THE
NORTH FLORIDA FAIR,
OCTOBER 1960. More than just
a county fair, this event takes in
a dozen north Florida counties
every autumn. There is
something for everyone. The
middle school kids and a brave
selection of parents love the
Tilt-a-Whirl, Pharoah's Fury,
the roller coasters, and that ride
that spins you around like a
clothes dryer while the floor
drops out. The rest of us just
ride the carousel.

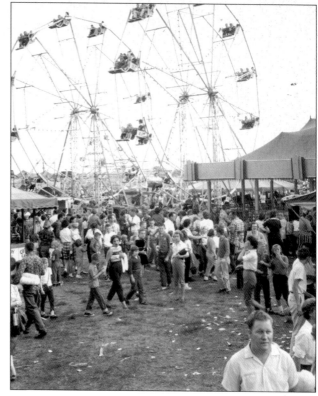

MIDWAY AT THE NORTH
FLORIDA FAIR, OCTOBER 1960.
Step right up! Carnival barkers
try to convince, often
successfully, high schoolers and
their dates to throw the
baseball, swing the sledge
hammer, shoot the ducks, and
win a prize.

ANIMALS AT THE NORTH FLORIDA FAIR, OCTOBER 1960. This young lad knows why agricultural fairs first started: animals. The cow barn, the pig barn (phew!), the sheep barn, the ducks, rabbits, turkeys, and petting zoo all fascinate a distinct segment of the carnival audience.

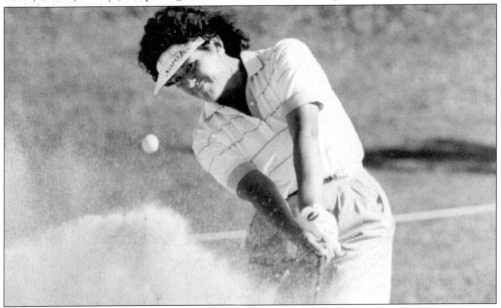

NANCY LOPEZ AT THE CENTEL CLASSIC, 1991. Killearn Country Club hosted one of the premier Ladies Professional Golf (LPGA) tournaments in the nation during the 1980s and early 1990s. The local telephone company supplied the prize money until they were bought out by Sprint, who ended the tournament in Tallahassee in 1993. The LPGA now goes to Daytona Beach for this event.

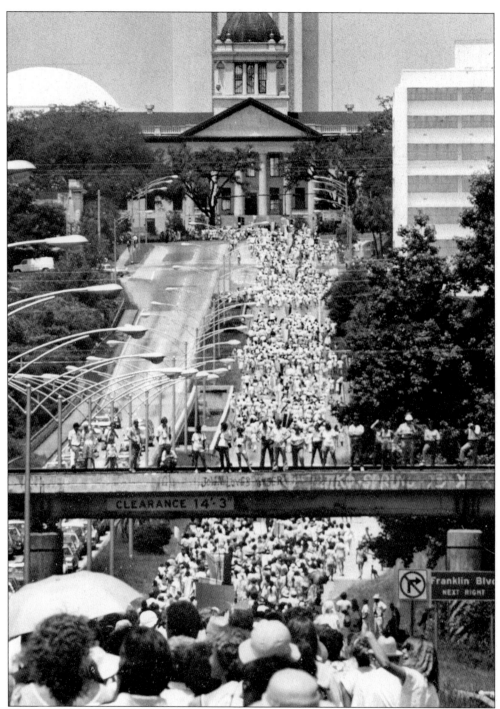

POLITICAL DEMONSTRATION ON APALACHEE PARKWAY, MARCH, 1982. When the legislature meets every year in March, April, and May, many people follow the issues and the bills. On this occasion the House and Senate debated ratifying the national Equal Rights Amendment (ERA). Despite the thousands of people present who supported the amendment, Senators voted it down.

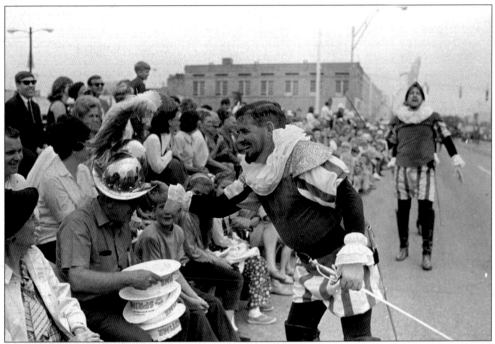

SPRINGTIME TALLAHASSEE FESTIVAL, MARCH 1970. Started in 1968, this preeminent city festival features a big, noisy, musical parade, Mardi Gras-style krewes or clubs who dress up and fling beads and candy, Shriners in little cars—well, you name it and it's in the parade. This krewe member, dressed like a Spanish explorer, practices a little audience participation.

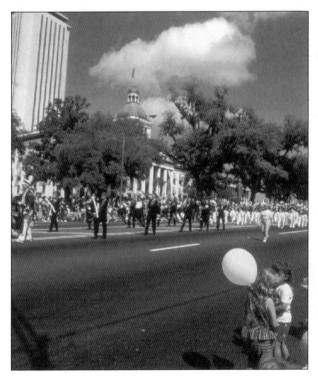

SPRINGTIME TALLAHASSEE PARADE, 1992. The parade route always runs down Tallahassee's main road, Monroe Street, with the reviewing stand for dignitaries at or near the old capitol building.

Springtime Tallahassee "In the Park," 1994. After the big parade, thousands of hungry visitors swarm to Park Avenue, Adams Street, and Duval Street to devour bratwurst, funnel cakes, gyros, and all kinds of snacks. Then they shop at the arts and crafts booths and visit the public service booths run by the police and fire departments, parks and recreation departments, and other city, county, and state agencies. Lots of pencils, key chains, and Frisbees get handed out.

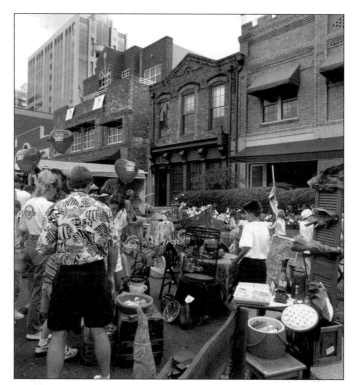

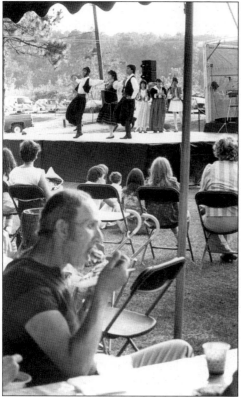

Greek Food Festival, October 25, 1985. Every year, the members of Holy Mother of God Greek Orthodox Church raise money for church and community projects by selling Greek-style food and beverages. They also demonstrate traditional Greek dances and music, and conduct tours of the church's beautiful ikon-decorated sanctuary. Thousands of Tallahasseans and out-of-towners participate.

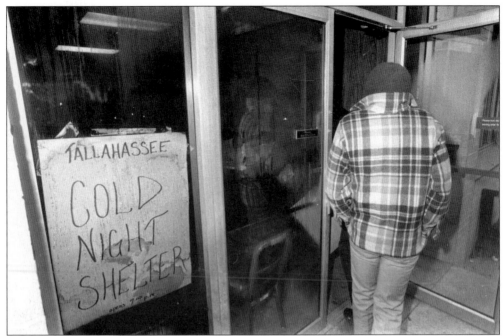

TALLAHASSEE COLD NIGHT SHELTER, 1989. Mel Eby started this organization to help the homeless, drifters, and down-on-their-luck folks. This early view of an important charitable organization shows a hand-lettered sign. Today there are beds, a professional marquee, a kitchen and laundry, and the opportunity to seek help in a well-organized facility. Many churches and community organizations volunteer their food and time at the shelter.

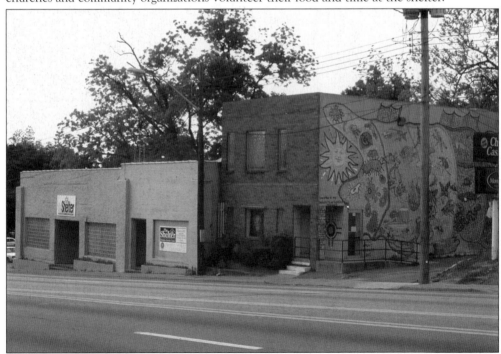

THE SHELTER, APRIL, 2003. (Author's collection.)

TALLAHASSEE TIGER SHARKS ICE HOCKEY GAME, FEBRUARY 26, 1999. The East Coast Hockey League formed to introduce the sport and excitement of ice hockey to the southeastern United States. Tallahassee's team played in the Civic Center from 1994 to March 2000. Though the Tiger Sharks ran into administrative problems and are now gone, other Southern cities continue to enjoy this "winter" sport. (Author's collection.)

OPERATION DESERT SHIELD, SEPTEMBER 14, 1990. Army Reserve soldiers of the 160th Military Police Battalion depart Tallahassee for Fort Benning, Georgia. They were preparing for deployment to Saudi Arabia during Operation Desert Shield (later Desert Storm).

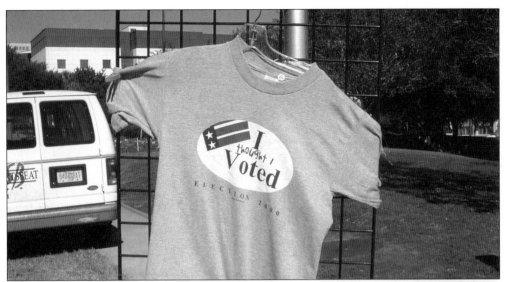

"I THOUGHT I VOTED," NOVEMBER 30, 2000. Election 2000 pitted George W. Bush against Al Gore. The state of Florida, with its 24 electoral votes, took 36 days to decide who won. This tee shirt did not take sides. Vendors sold it on Monroe Street directly across from the state capitol building to tourists, reporters, and politicians.

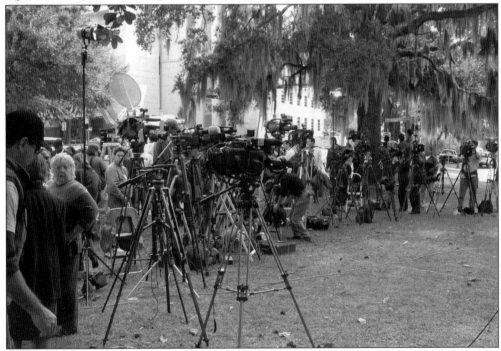

PRESS CONFERENCE DURING ELECTION 2000, NOVEMBER 28, 2000. Literally the entire world sent reporters to Tallahassee to cover the presidential election standoff. Japanese TV staked out a spot on the Florida Supreme Court lawn just north of the main entrance for the duration of the event. This crowd of camera operators and reporters appears to be gathered in the green space next to the Florida Vietnam War Memorial, across the street from the capitol. An announcement will be made shortly.

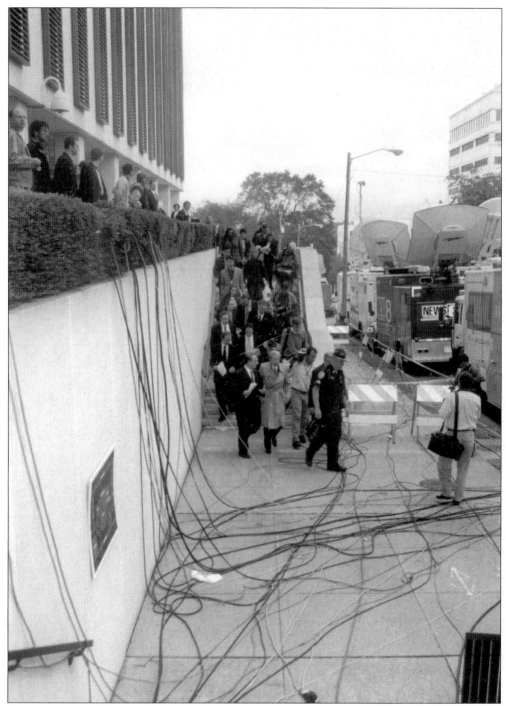

ELECTION 2000 TELEVISION COVERAGE, NOVEMBER 2000. More than 130 satellite up-link trucks parked around the Florida state capitol and its environs during the presidential election dispute. Most of them seem to be getting free electricity from outlets in the capitol complex. This photograph shows the trucks only two rows deep; by early December, they parked three rows deep.

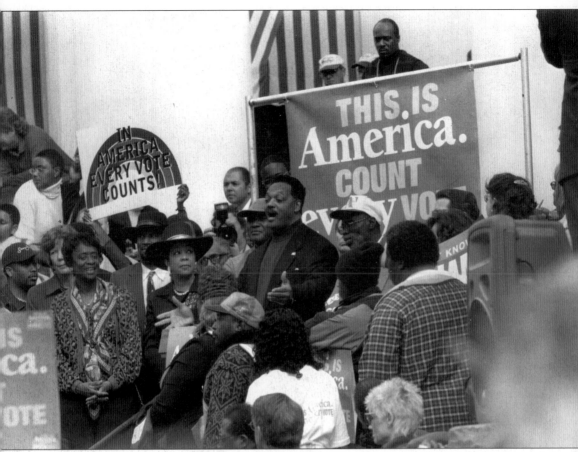

ELECTION 2000 RALLY, LATE NOVEMBER 2000. Many nationally known and influential people came to Tallahassee during the vote recounts of November and December. Jesse Jackson, of Chicago Illinois's Rainbow Coalition and longtime civil rights activist, came several times. On this occasion he spoke at the historic old capitol building. Standing above and behind the Reverend Jackson (at the "This is America. Count Every Vote" sign) is Tallahassean Sam Wilson. (Courtesy of Keith Vipperman.)

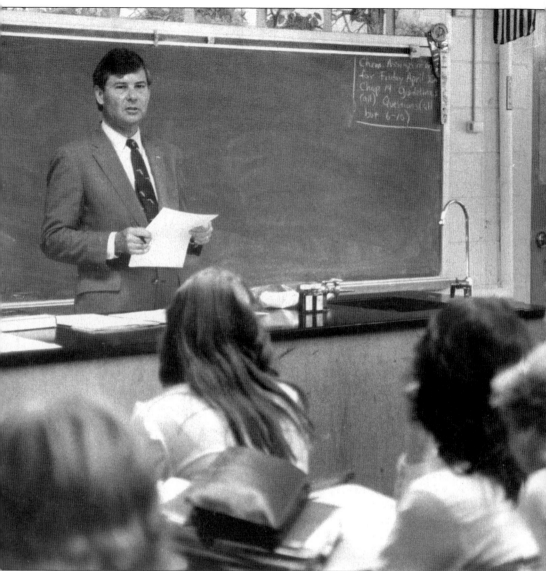

GOV. BOB GRAHAM AT RICKARDS HIGH SCHOOL. APRIL 22, 1983. Since 1977 Bob Graham has performed "work days" on a regular basis. At first a campaign strategy, he found that he learned a great deal from the people he worked with and the jobs he performed. On this day he worked as a substitute teacher at a Tallahassee high school. He continued to perform work days as Florida's United States Senator for three terms. In the spring of 2003, Graham started a campaign for the Democratic Party nomination for President.

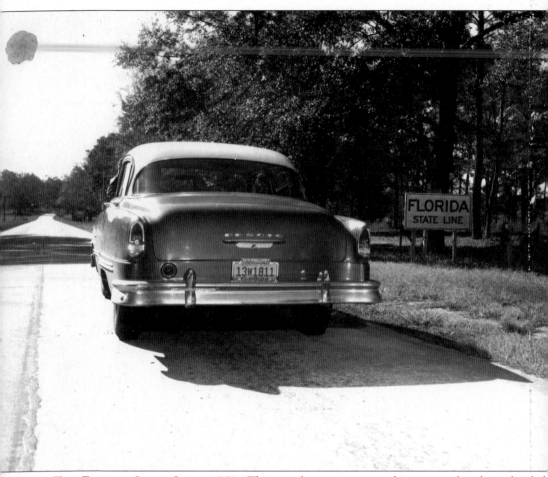

THE FLORIDA STATE LINE, 1953. This two-lane country road is now a four-lane divided highway, and the DeSoto Automobile Company is long gone. But Tallahassee is still about 20 miles down the road, and the city is looking forward to its bicentennial as Florida's capital city in 2024.